TAVISTOCK
THROUGH TIME
Gerry Woodcock

AMBERLEY PUBLISHING

First published 2009

Amberley Publishing
Cirencester Road, Chalford,
Stroud, Gloucestershire, GL6 8PE

www.amberley-books.com

British Library Cataloguing in Publication Data.
A catalogue record for this book is available from the British Library.

ISBN 978 1 84868 396 9

Typesetting and Origination by Amberley Publishing.
Printed in Great Britain.

Introduction

Tavistock, the settlement on the River Tavy, began its recorded history a thousand years ago. It was under the shadow of the great Benedictine Abbey, founded in AD 974, that the town was established, where the Fishlake, tumbling down the Billingsbear Valley from its Hurdwick source, neared its destination, the right bank of the Tavy. In the thirteenth century this small community established a market, gained borough status, and began to send MPs to parliament. It remained, however, totally dependant on the wealth, benevolence and will of the monks and their abbot. The closing of the monasteries in 1539 brought about a change of ownership. The monastic lands and properties were given, by the King, to John Russell, the ancestor of a long line of Earls, later Dukes, of Bedford. This dynasty continued to control the fortunes of the town until the early years of the twentieth century, then, on the eve of the First World War, the eleventh Duke of Bedford sold the bulk of his Tavistock property. Shops, houses, inns, offices, farms, and open spaces were redistributed among a wide range of new owners, many of whom were former tenants. The local council bought a number of buildings and amenities and these have remained in public ownership. During the last century the town lost the patronage of the Russells. It did not lose the indelible mark of the Russell era. The Bedford fingerprint remains, not only on the physical features of the town, but on many aspects of its institutional life. The imprint of the more distant centuries, when the patrons were the abbots, is rather less obvious, but still real.

In the nineteenth century the town grew rapidly, in response to the development of the local mining enterprises. The population increased from 3,420 in 1801 to 8,912 in 1861, although it fell back thereafter as the copper boom collapsed and depression set in. It was not until the 1970s that the population returned to its level of a century earlier. The figure now exceeds 12,000. The last century and a half have seen enormous changes, as well as experiencing

wars, economic ups-and-downs, and momentous local events like the end of the patronage of the Bedfords. Improvements in transport and communications led to major modifications in everyday life. New patterns of education, health care, and welfare were developed, clubs and societies mushroomed, a system of accountable local government emerged, and churches and chapels flourished as centres of social activity as well as worship. Meanwhile the very appearance of the town undertook radical transformation, with the development of Plymouth Road, Duke Street, Drake Road and Market Road, and the construction of the town hall and the Pannier Market. New estates sprang up, the extent of which, in the post-war period, may be gauged from the fact that in 1950 there were 112 roads or streets in the town that were recognised as postal addresses. By 2000 there were 204. It is our good fortune that the camera made its appearance in time to record so many of these developments. Photography is a tool that helps us to explain what we were, and thereby helps us to understand what we are.

Unless otherwise indicated in the caption, the older picture on each page dates from the period between 1890 and 1910, and the newer picture from the period between 1998 and 2009.

I gratefully acknowledge the camera-work of Graham Kirkpatrick and of my wife, and am indebted to the following for the loan or gift of material: Tavistock Museum, Tavistock Association Football Club, Jack Clotworthy, Jack Davey, Bill Foster, Rod Martin, Michael Parriss, John Snell, George Wimpey. The words are mine and I must accept responsibility for any errors.

The book is dedicated to the people of Tavistock present and past, whether native-born or, like me, appreciative adopted sons.

Gerry Woodcock
Tavistock 2009

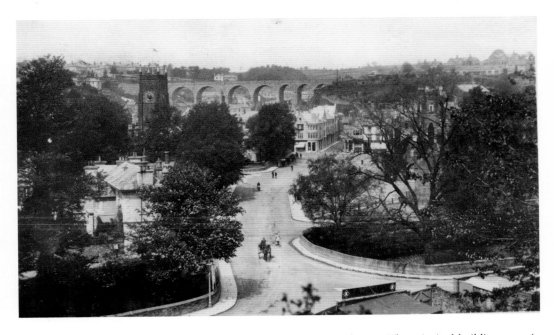

Two glimpses to show a developing town centre between 1910 and 1974. The principal buildings remain unchanged, and the road, running south-north, can be followed from Abbey Bridge, past Bedford Square, and up Drake Road. The railway viaduct has survived, but is experiencing redundancy before becoming a public walkway in 1988. A major transformation awaits Bedford Square, which, by the end of the century, has become traffic free. Both pictures were taken from Deerpark, an area of late twentieth-century development, where once the monks of Tavistock Abbey kept some forty head of game.

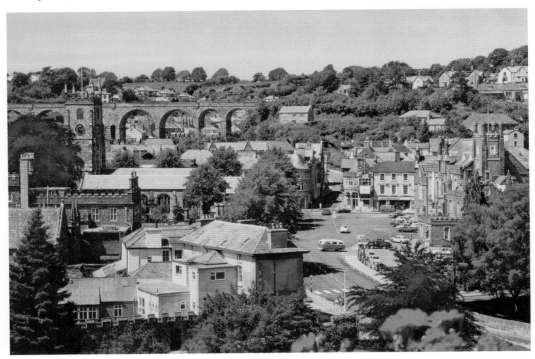

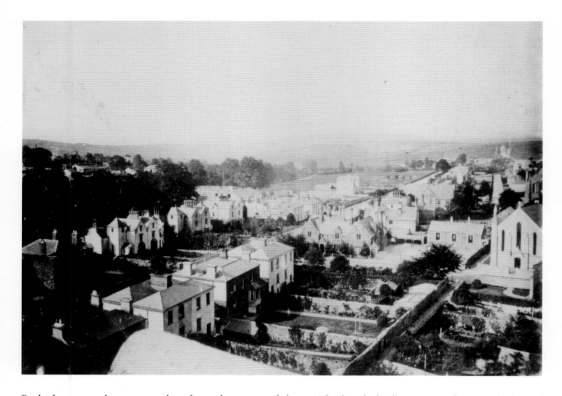

Both these snapshots were taken from the tower of the parish church, looking west. The straight line of Plymouth Road, developed in the 1860s, stretches past The Meadows and up to Fitzford. It passes the foot of Russell Street, giving a clear picture, in the 1890s photograph, of the grammar school and the United Methodist chapel. The 1990s picture shows also the Crown Centre, built in 1939 as the Carlton Cinema, and destined to be replaced in 2007 by residential development.

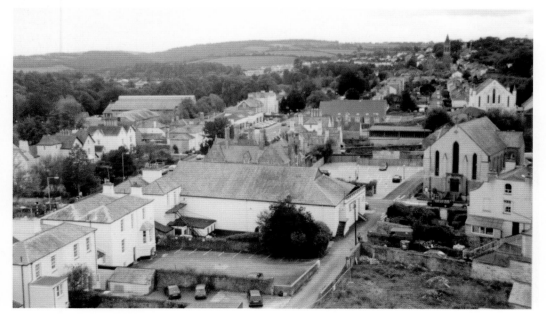

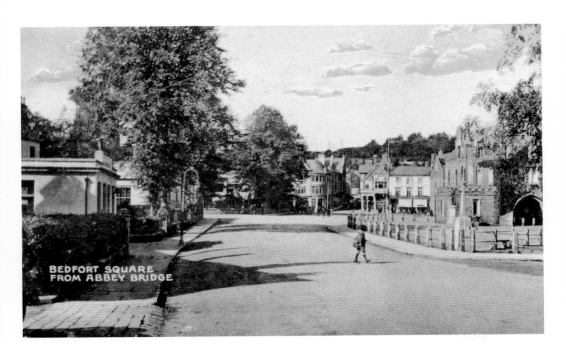

BEDFORT SQUARE
FROM ABBEY BRIDGE

The vantage-point is Abbey Bridge. Above: a late afternoon in the summer of 1922. The photographer catches the scene as a lone schoolboy makes his way home across a deserted Abbey Place. Beyond is Bedford Square, at the north end of which a parade engages the interest of a few bystanders. The only motor car lies hidden behind the newly-dedicated war memorial. Below: the same view on an early summer afternoon in 1998.

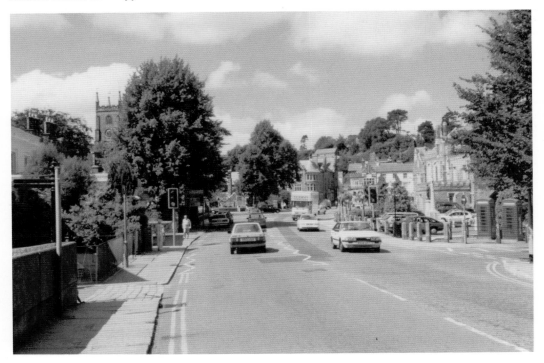

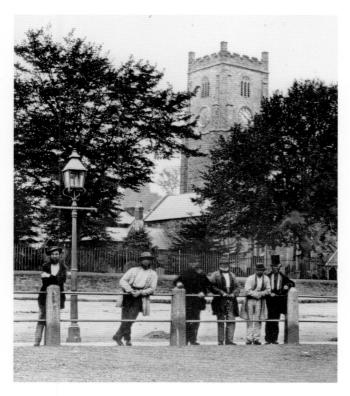

A quiet mid-morning in about 1890. Variously hatted, a group gathers near the entrance to Guildhall Square. Unhurried, but perhaps curious about the new-fangled camera machine that is pointing at them, they lean on the railings, opposite St Eustachius's.

Fast-forward to 2008, and a group of volunteers, hatless this time, occupy the same positions. The gas lamp has gone, but the railing and the granite posts survive. Cars and street furniture abound, and the churchyard has lost its perimeter railing.

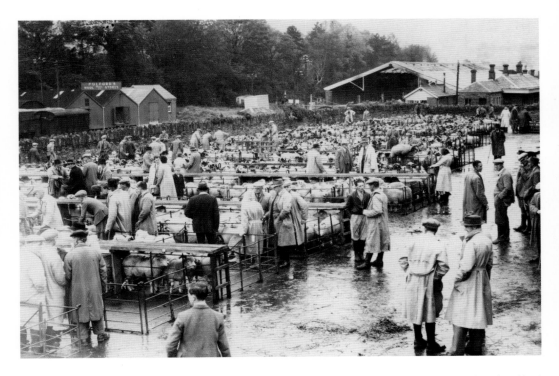

Equally popular with residents and visitors, the Pannier Market was built by the seventh Duke of Bedford as part of his major town centre reconstruction. Opened in 1862, it provided accommodation for a concentration of market activities that had hitherto been dispersed. The lower picture shows it a few days before Christmas 2008. It did not, of course, replace the cattle market, sited from the early 1860s off Whitchurch Road. The upper picture is a view of the cattle market in the 1950s, with, in the background, the former GWR station, which was to close in 1962.

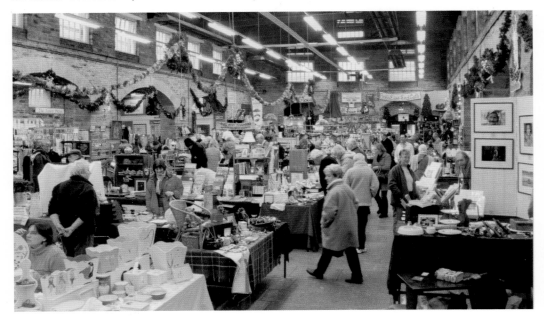

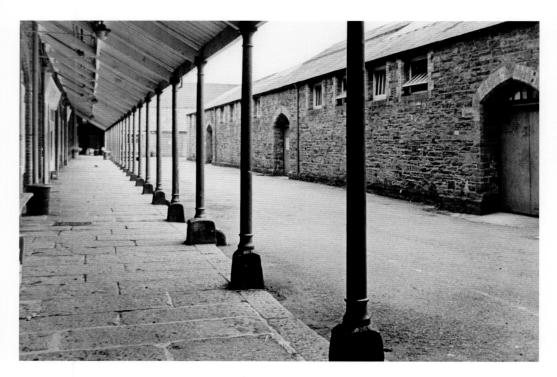

Opened in October 1862 with a banquet for those who had worked on its construction, the Pannier Market featured an encircling road. On one side of the perimeter is the town hall, while shops occupy the other three sides. Here, on the north side, a colonnade gives access to Duke Street. The whole market precinct has, in recent years, become increasingly lively and busy, as the two pictures illustrate, the earlier one dating from the 1960s and the later one from 2008.

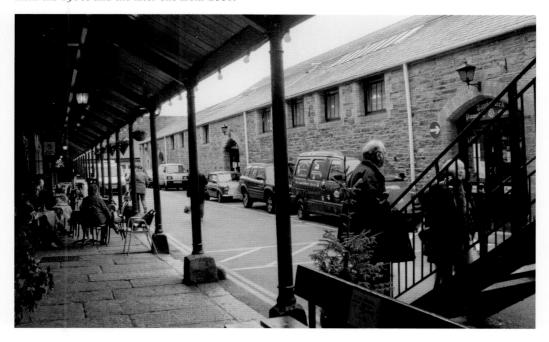

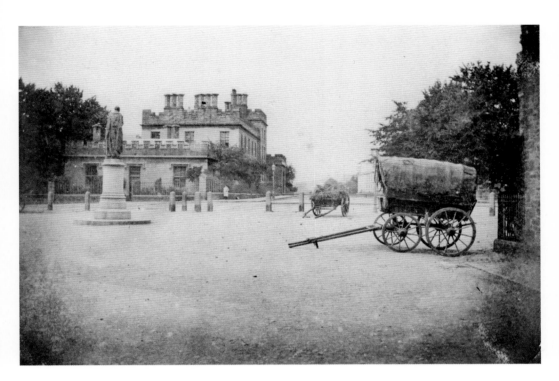

The camera, in Guildhall Square, points west, towards and along the long, straight Plymouth Road. On the left is the building, on the corner of Plymouth Road and Abbey Rise, which, between the 1820s and the 1960s, housed the office of the Duke of Bedford's Tavistock Estate. The Duke's steward was, arguably, the most powerful resident in the town. Beyond is the Bedford Hotel. A century separates the two pictures, but they both show the Square being used for parking—plus ça change!

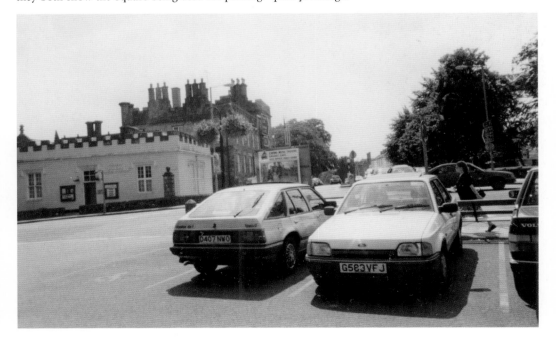

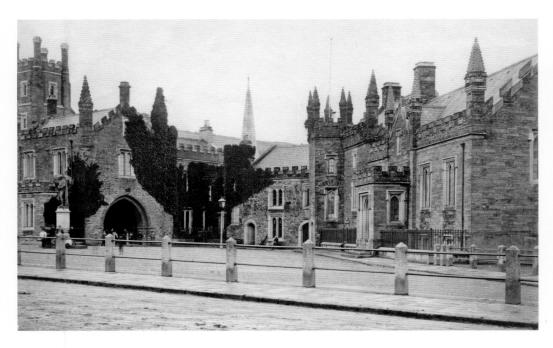

The range of public buildings that form the backcloth to Guildhall Square, to the statue of the seventh Duke of Bedford and, more recently, to the war memorial, dates from the middle years of the nineteenth century. The earlier picture shows the Guildhall on the right adjoining the premises of the police station and the fire brigade. A contemporary scene shows that both the fire station and the spire of the congregational church have disappeared. The Guildhall ceased to serve as a lawcourt in 2000, and has since then been searching for a function.

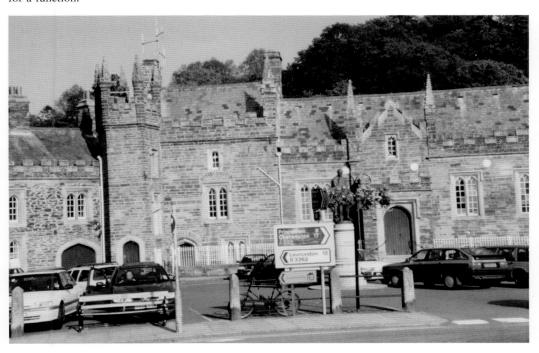

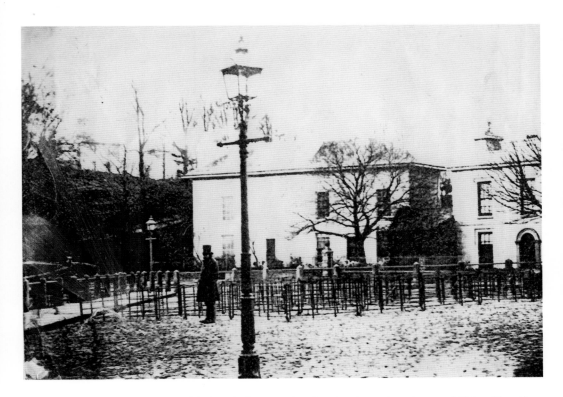

William Merrifield was a pioneer Tavistock photographer. In 1860 he took a picture of Abbey Place from across the road in Guildhall Square. The new cattle market had not yet opened, and the sheep pens in the square indicate clearly one of its traditional functions. The building on the right has just (in 1859) become the post office, and so it was to remain. By the time of the second picture, in 2008, the other building had, for more than a century, been the home of the West Devon Club. In neither picture has the identity of the mysterious bystander been discovered.

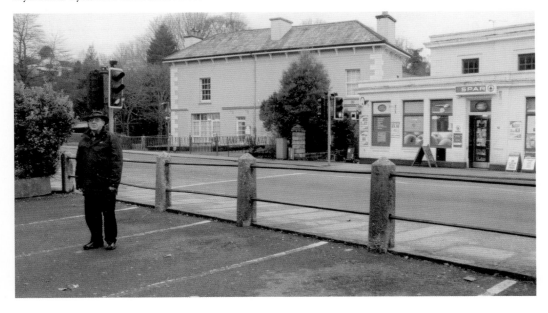

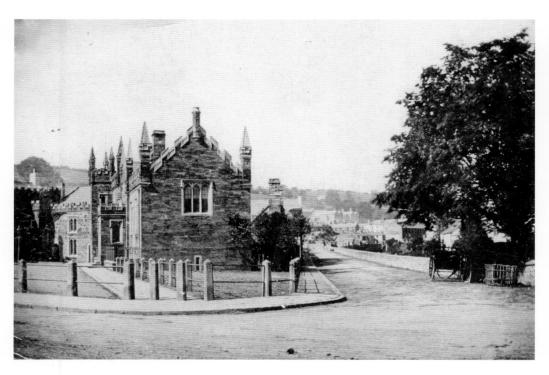

The construction of the Pannier Market in the early 1860s was achieved by channelling the flow of the river. Hitherto the Tavy had, at this point, taken two courses round a mid-stream island. The island was now to disappear. The right-hand stream was blocked and embanked, and emerged as a thoroughfare to serve the market. This is, appropriately, Market Road. It passes alongside the market before turning to the left, at which point there stood, from the thirteenth to the eighteenth century, the first town bridge.

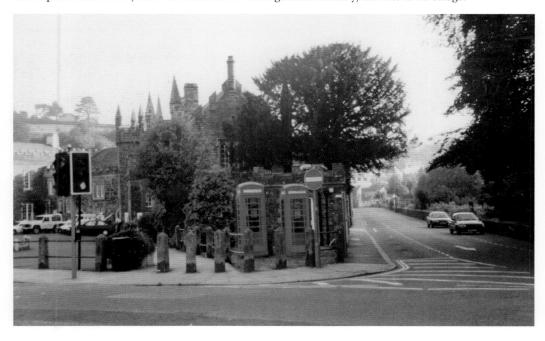

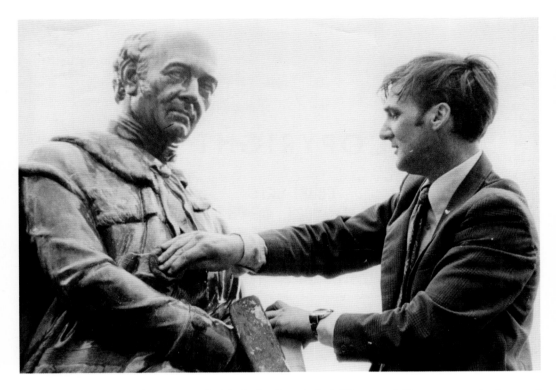

The words about Wren that are inscribed in St. Paul's cathedral, "If you seek his monument, look around you", might well apply equally to Francis the seventh Duke of Bedford, whose statue has adorned Guildhall Square since 1864. He is seen here, a hundred years on, receiving one of his occasional 'face lifts'. The lower picture, taken from the church tower, shows a part of his legacy, the area that he developed, flanked by the river and by a fashionable new shopping street, appropriately named "Duke Street".

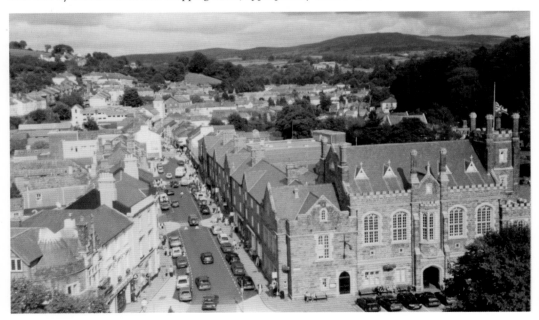

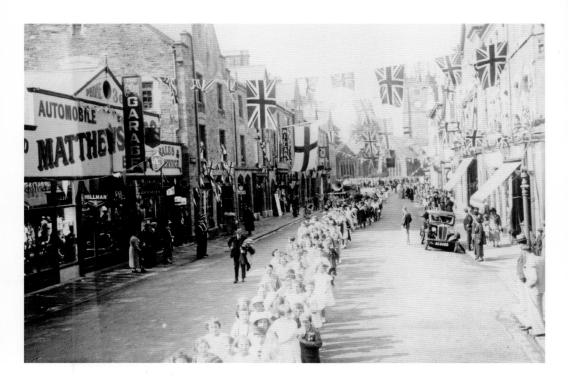

Duke Street emerged from the major redevelopments undertaken by the Bedford Office in the early 1860s. Both pictures are taken looking west at the point at which the bottle of Duke Street becomes the neck of Brook Street. Celebrations are in order in both 1937 and 1998. The upper picture captures the scene on the day of the coronation of George VI. The "furry dance" was introduced to Tavistock from his native Helston by George Anthony, at the time a councillor and the GWR stationmaster. The lower photograph shows the street with carnival week decorations.

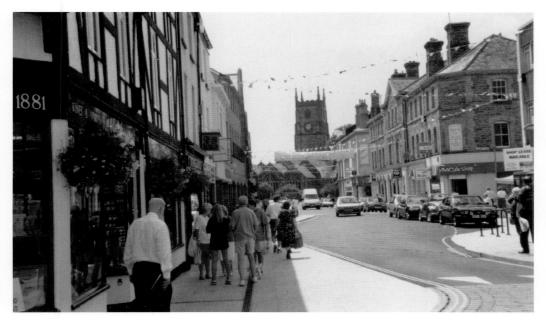

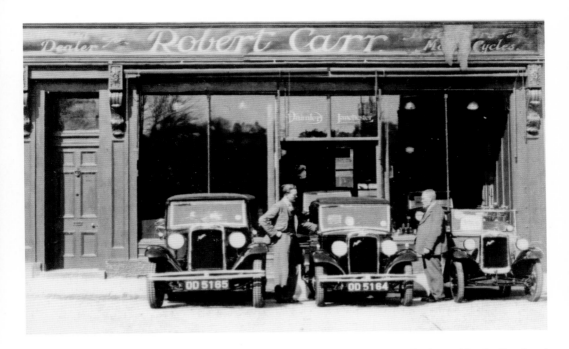

The local branch of NatWest is one of the four banks huddled together near the foot of Drake Road and facing Bedford Square. It has been there since 1964. Before that the premises had, for some years, housed Perraton's Café, a town centre landmark and popular meeting place. Back in the early 1930s the site was, for a time, a showroom for Robert Carr, a motor engineer who had established a garage business on Parkwood Road in 1923. The Carr story was to be continued on Plymouth Road.

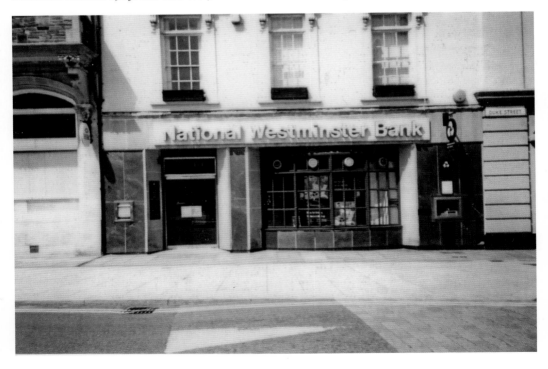

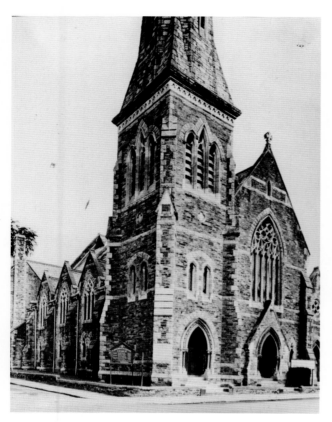

A site near the meeting of Duke Street and Brook Street, on the north side of the road, was occupied for 90 years from 1873 by a Congregational church with a spire 133 feet high. In the early 1960s the Congregationalists, with a declining congregation, found it increasingly difficult to maintain such a large edifice. They sold out to the Pearl Assurance Company, and moved into more modestly sized accommodation in the Russell Street chapel. The company demolished the church in 1964 and replaced it by an alternative structure, shown below.

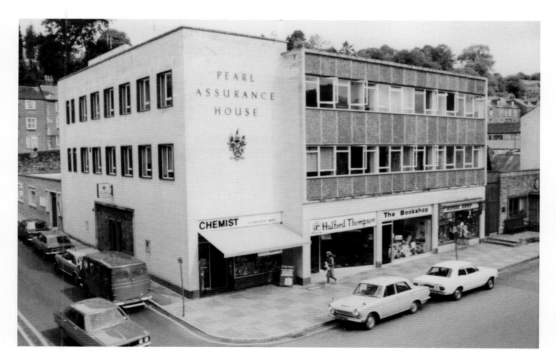

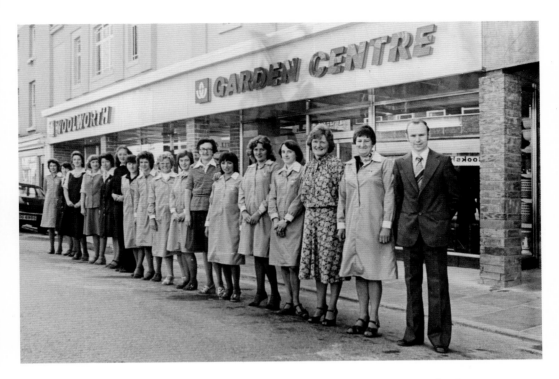

Woolworth's arrived in Tavistock in 1935, and occupied its prime Duke Street site for the next 73 years. The period of greatest success and expansion for this well loved store came in the years after the war. The opening of the Garden Centre, recorded above, occurred in the 1970s. The harsh economic climate of 2008 brought the closure of "Woolies" nationwide, and the Tavistock store closed in the last week of 2008, though not before, as the lower picture reveals, a car had, on Christmas Eve, crashed into a shop-front window.

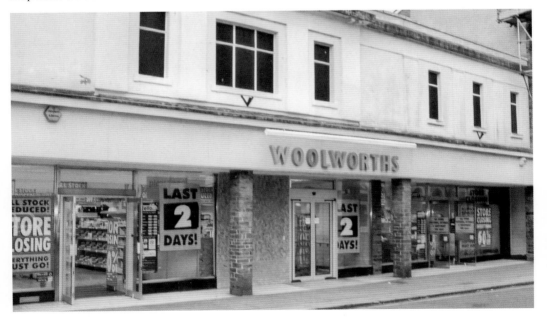

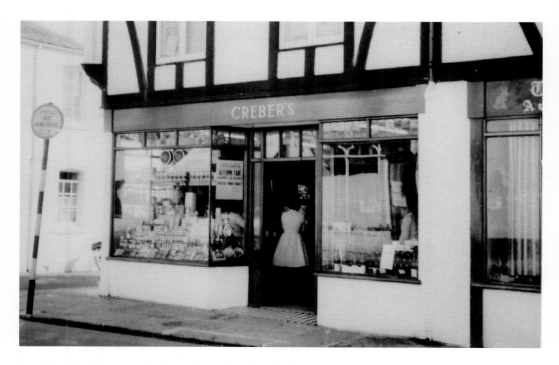

In 1881 John Carter, a middle-aged ex-miner, founded a grocery store. His daughter Winifred carried on the business with her husband, Henry Creber, and Creber's it became, as it remains two generations on. "Creber's Corner", on the south side of Duke Street, became a well-known spot, noted not least for the aroma of coffee, and the business strengthened a reputation, local, national, and ultimately international, for quality produce and service. In 1959 there was a doubling in the size of the emporium, shortly after the first picture was taken.

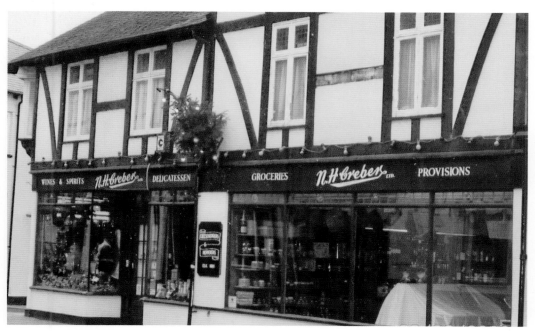

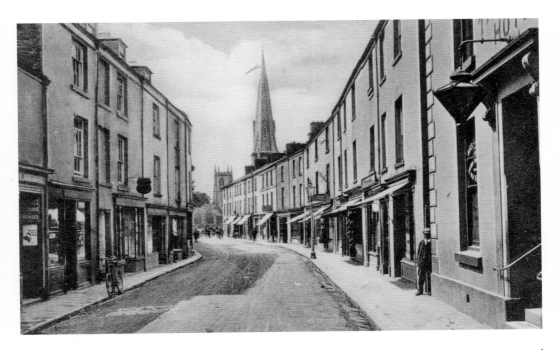

Looking west along Brook Street. In 1900 there were 38 businesses in this street, there were 5 grocers; 3 of each of confectioners, drapers, and innkeepers; 2 of each of fruiterers, boot makers, butchers, and general shopkeepers; and 1 ironmonger, watchmaker, stonemason, cabinet maker, coach builder, gasfitter, saddler, coal merchant, tailor, builder, decorator, glass dealer, as well as an insurance agency, a coffee house, a brewery, and a fancy repository. Both pictures are taken from the steps of the Tavistock Inn.

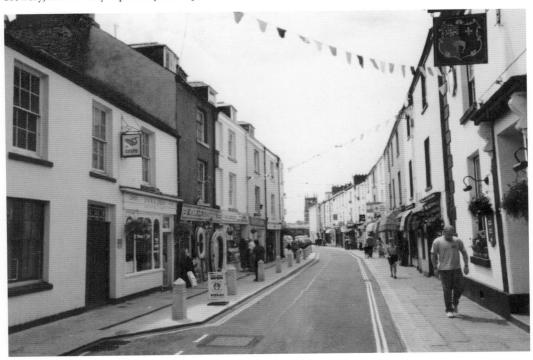

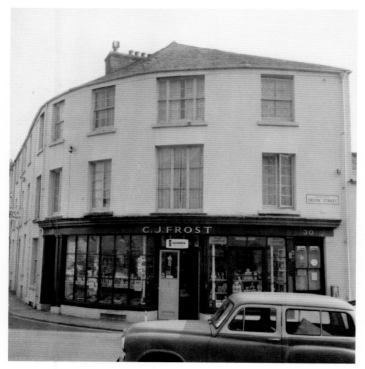

On the corner of Brook Street and Vigo Bridge Road, opposite where a supermarket was to appear in 1986, Charles J Frost, greengrocer and fruiterer, ran a well-known business for many years from the 1930s. In 1938 he married Hilda Gawman, a local girl. At the time of writing she is in good health and living within a stone's throw of the shop. Meanwhile there have been a succession of changes to the premises, which are now occupied by an estate agency.

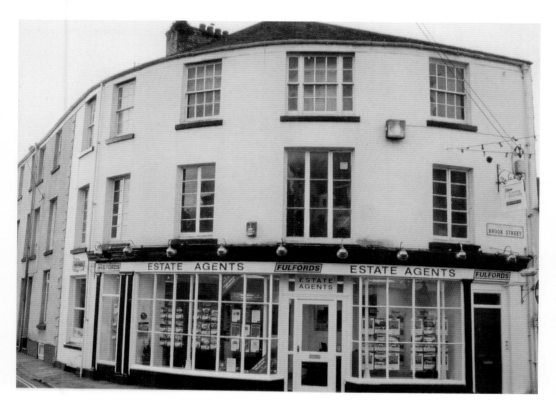

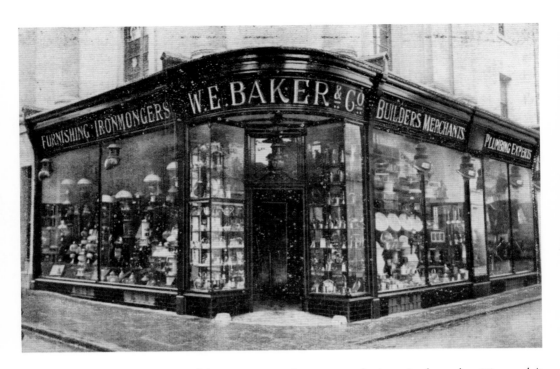

William Edmund Baker established his town centre ironmongery business in the early 1860s, and it remained a family concern, albeit a constantly expanding one, for a century. Its founder, Methodist, Liberal, abstainer, and philanthropist, died at his home on Courtenay Road in 1906. The popular corner site, a few yards away from the parish church, is shown in about 1920. The popular refreshment-house, with its pasty specialities, is the latest of the successor businesses on the site.

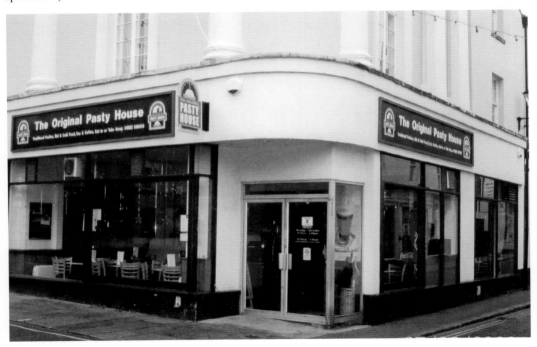

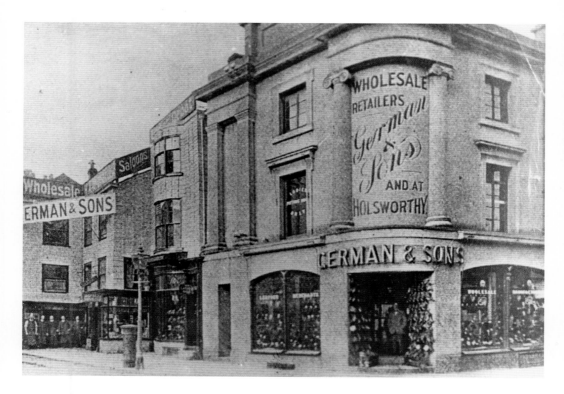

John Bird German founded, in the 1870s, a family business at the southern end of Market Street that traded on until the eve of the Second World War. Boot and shoe makers, they were particularly proud of the "Dartmoor", which they advertised as "the strongest boot in the world". A later generation will remember the site as providing the premises of C . W. Beckerleg, purveyor of all things electrical. The earlier, turn-of-the-century picture features a gas lamp that has disappeared and a post-box that has, mercifully, survived.

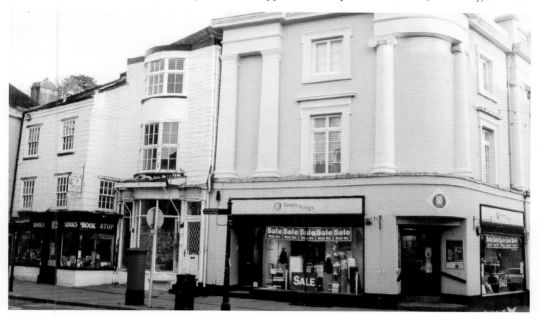

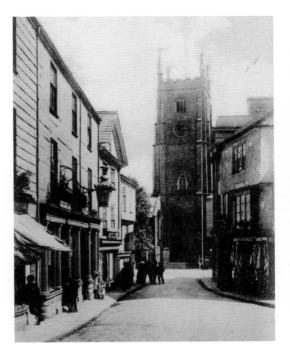

The small community that grew, from the tenth century onward, alongside the enclosed precinct of Tavistock Abbey, had its commercial centre, with its on-street trading, here. Market Street remained the centre of such activity until the construction of the Pannier Market in the middle of the nineteenth century. When the earlier picture of Market Street was taken, in 1917, this relatively short street was home to a bank, the Co-op, 2 boot makers, 2 grocers, 2 hairdressers, a basket maker, a dress maker, a tobacconist, a furniture dealer and a furniture remover, a butcher, a baker, a stationer, an insurance agent, a painter, a confectioner, an outfitter, and a draper.

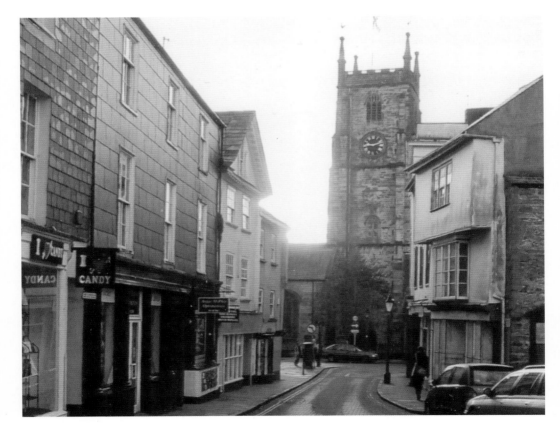

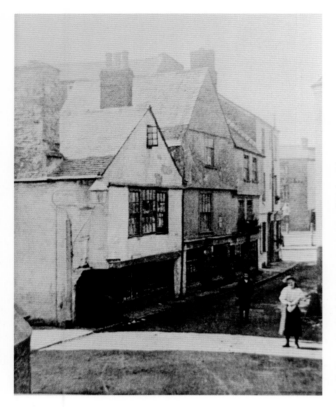

Pym Street was named in honour of John Pym, the seventeenth-century parliamentary leader who represented Tavistock in parliament. In the older picture the young lady is standing outside the Temperance Hotel, opened in 1838 and closed in 1928, before being transformed, in turn, into council offices and public house. The second picture shows two major additions to the scene on the other side of the road, the offices of the *Tavistock Gazette*, and the Masonic Hall. They date from 1907 and 1901 respectively. The latter replaced the dilapidated building, said to be of great age, in the foreground in the earlier picture.

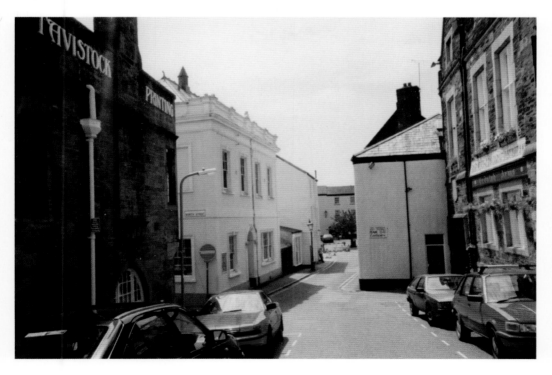

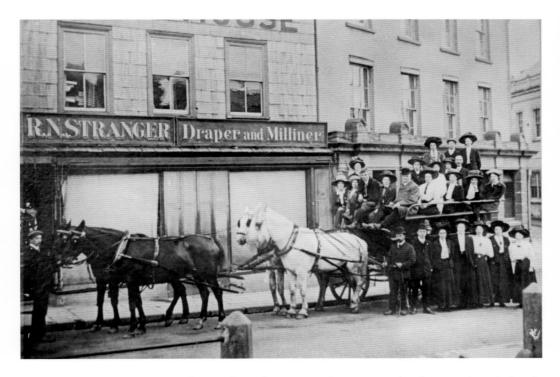

Richard Northcott Stranger came from Holsworthy to Tavistock in 1898, and took over a draper's shop in Market Street before moving into premises at No 2 Pym Street, where he called his emporium "Manchester House". The scene, around 1913, when the shop closed for the staff outing, gives an indication of how labour-intensive such businesses were. In the last years of the twentieth century this was the address of "Bill the Baker". Bill Foster, who ran this popular business, is shown here in 2001, the year in which he retired and moved to live in France.

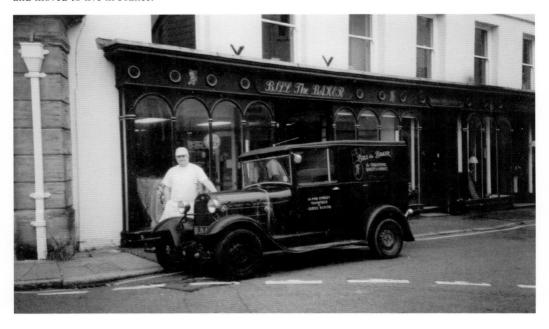

The London and South Western Railway came to Tavistock in 1890 and established a station on high ground to the north of the town centre. It was felt necessary to construct a new road from Bedford Square to provide adequate access to the station. The route was opened up by removing some buildings on the north side of the square. Impressive new buildings, including the town council offices, appeared on both sides of the new road, which was named Drake Road. A sense of purpose may be observed in the newer picture. It is less evident in the older one.

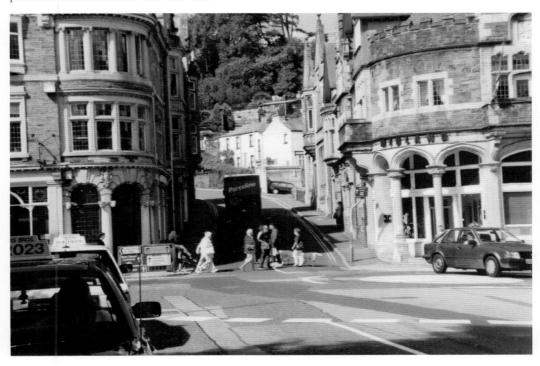

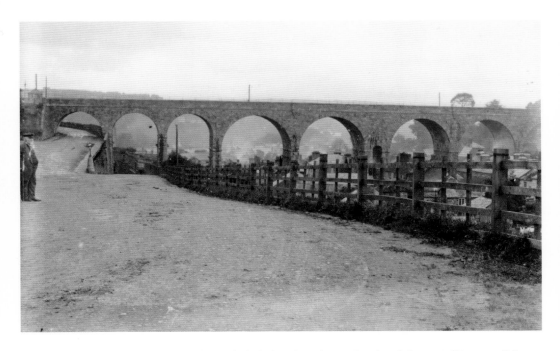

Drake Road, constructed in 1890, ultimately linked with Trelawny Road and the top of Bannawell Street, but its main duty was to serve the railway station. The planners of the new line had been faced with major engineering problems. One was the task of spanning the valley from Kilworthy Hill to Glanville Road, a challenge that was met by the construction of a 480 feet long viaduct. This eight-arched construction is shown, above, in its first year. The line closed in 1968. Twenty years later the viaduct was re-opened as a walkway. The sinister figures in both pictures continue to defy detection.

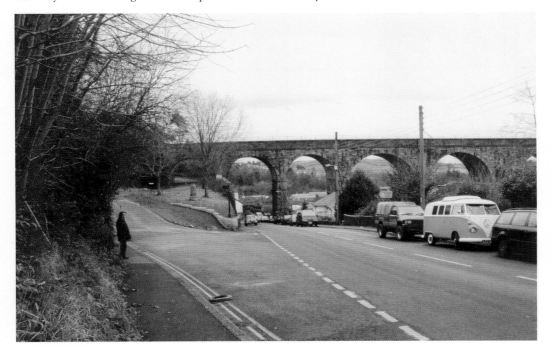

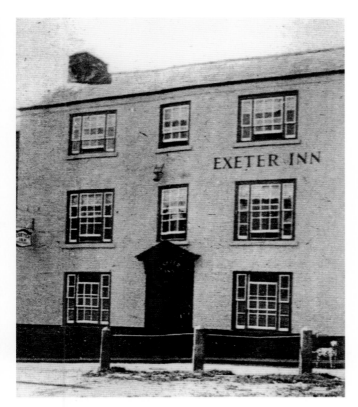

In the first half of the nineteenth century the Exeter Inn in King Street, one of a cluster of inns within a few yards of each other, was seen as second in prestige and importance only to the Bedford Hotel. A coaching inn, it received a daily coach from Plymouth at one o'clock and despatched it on its return journey at five o'clock. On alternate days there were services to and from Barnstaple. This era came to an abrupt end when the railway arrived. Soon after the end of the Second World War the inn became the headquarters of the local branch of the Royal British Legion.

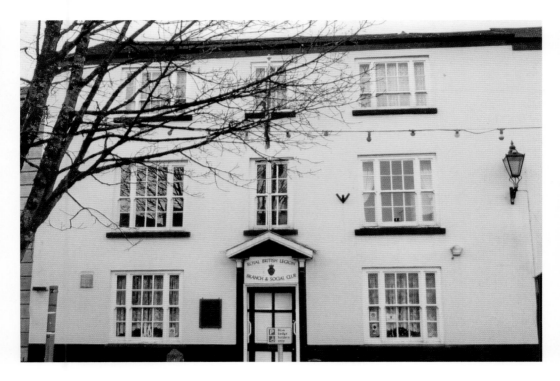

Number 11 King Street, or Lower Back Street as it was known in the nineteenth century, was a baker's shop from the 1850s. Until the 1890s the business was run by the Collins family, and thereafter it came to the Wilton family, three generations of whom continued the bakery tradition up to the Second World War. The upper picture features Francis and Emma Wilton. Emma was to run the business on her own through the inter-war years. The present-day business at No 11 continues a tradition, but with a contemporary flavour.

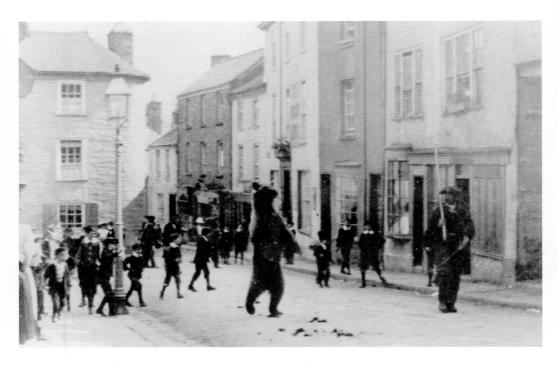

King Street then and now. In the old picture there are two features that are, perhaps, even more interesting than the performing bear, or his trainer, or the attendant urchins. On the extreme right Madge Lane begins its climb to Glanville Road by passing under Number 1 King Street. Secondly the old Union Inn and two other taverns mark the site to be occupied, from 1918, by the new Union Inn. The original Union Inn was so named to mark the creation, in 1801, of the United Kingdom of Britain and Ireland.

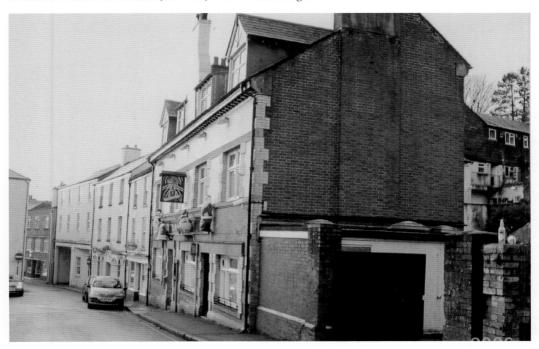

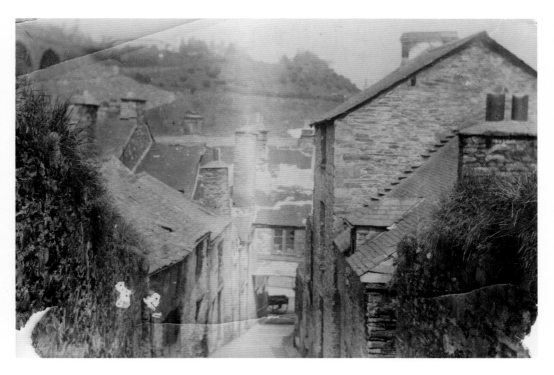

Madge Lane. What has not changed over the years is the steepness of this narrow lane. It derives its name from its position as the first stretch on the route westward out of the town towards the lazar house of St Mary Magdalen, the leper hospital that occupied a site later to be known as Mount Ford. The older picture shows, at the foot of the lane, a building extending across it, leaving a low passage way beneath. On the high ground, to the left, may be glimpsed the newly-constructed railway viaduct and the railway site.

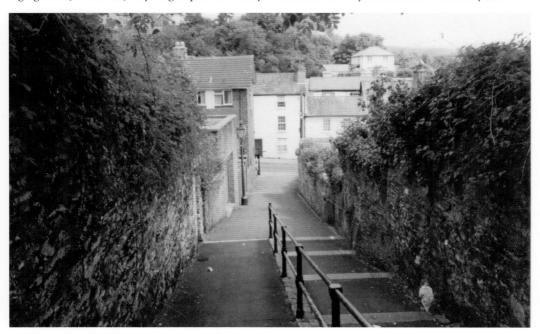

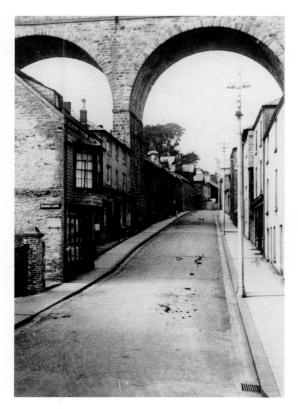

Who Banna was we do not know, but he had a spring, and by the fourteenth century it had given its name to a district. Always one of the town's most populous thoroughfares, Bannawell Street at the beginning of the twentieth century accommodated 100 families in 78 dwellings. Three boot-makers were among the tradesmen operating here; the little boy is standing outside the business of one of them, James Acton at No 4. At the top of the street, with the postal address of No 42, was the Union Workhouse, opened in 1838. After its closure, in 1961, the premises were developed for residential purposes as Russell Court, and are shown here today.

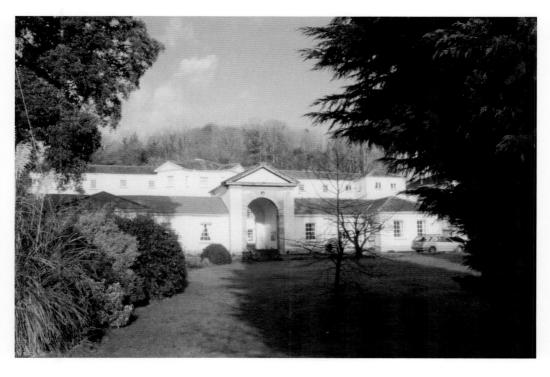

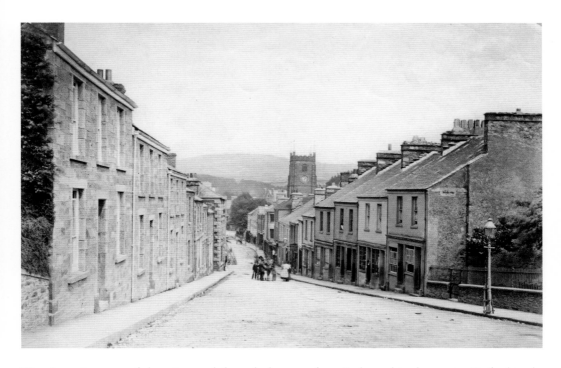

West Street is a part of the spine-road through the town from Parkwood in the east to Fitzford in the west. Above: in the 1870s. It is, perhaps, a Sunday lunchtime, as the street is quiet. A little knot of people has gathered round a cart outside Jane Ridgway's haberdashery, just above the Cornish Arms. Cox Tor smiles down on a town taking a midday nap. Below: the vantage-point is again the foot of Rocky Hill, previously known as Cake's Hill. Many of the buildings remain familiar, and Cox Tor smiles on, but the scene is busier and noisier.

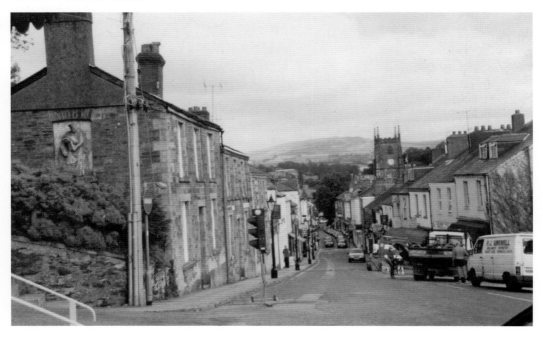

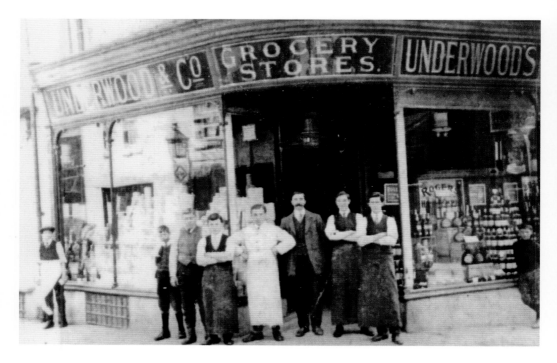

Trading as "Underwood and Co (Plymouth) Ltd", this enterprising grocery concern had, by 1930, established nine outlets in the city and the immediate area. The Tavistock branch arrived on the eve of the First World War, to take its place as one of 52 businesses operating in West Street in the early years of the century. Above: the staff outside the newly opened emporium at the corner of Russell Street. It fell victim to the self-service revolution of the 1970s. Below: the contemporary scene.

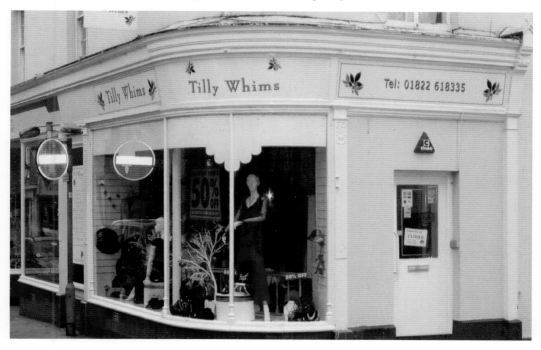

About halfway up West Street, on its south side and opposite the foot of Rocky Hill, is a site that has seen considerable changes over the last two centuries. It has housed, in turn, in the eighteenth century, an almshouse and a Methodist meeting house; in the nineteenth century an elementary school and a school of art; and in the twentieth century a church hall, a gospel hall, and a residential development. The pictures are of the church hall, opened in 1933 and shown here in 1970, and of Devonshire House, built in 1998.

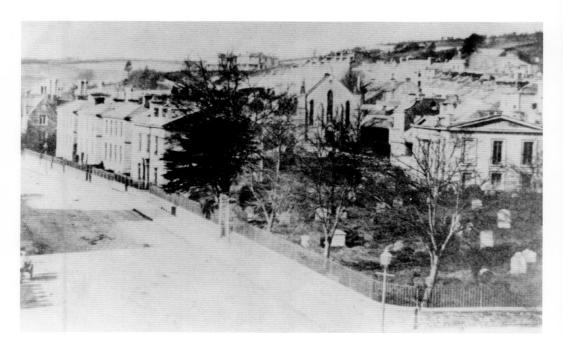

Views from a first floor window above Court Gate of the junction of Plymouth Road and Bedford Square in a) 1862, and b) 2000. In the early picture, one of the oldest surviving photographic images of Tavistock, the Bedford Hotel casts its shadow across the road, and on the extreme left is the grammar school, opened 24 years earlier. The churchyard, fenced and tombstoned, presents a rather more wild appearance than later ages were to find acceptable. The lime trees had been planted to mark the coronation of Queen Victoria in 1838.

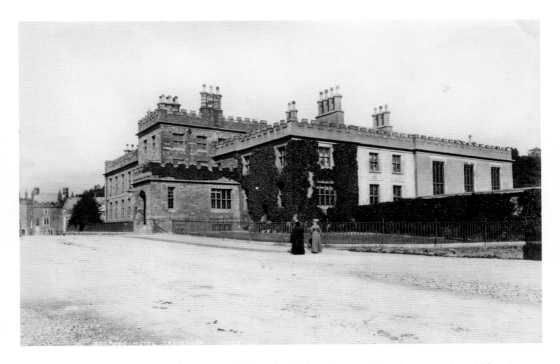

The Bedford Hotel was an inn from 1822. Before that it had been a private home, and, as Abbey House, was for some years the residence of the steward of the Duke of Bedford. Adapted to its new function, it quickly became the town's leading hostelry, while retaining some features of the "pompous dwelling house" that the vicar of the parish had described in a letter to the Dean of Exeter in 1750.

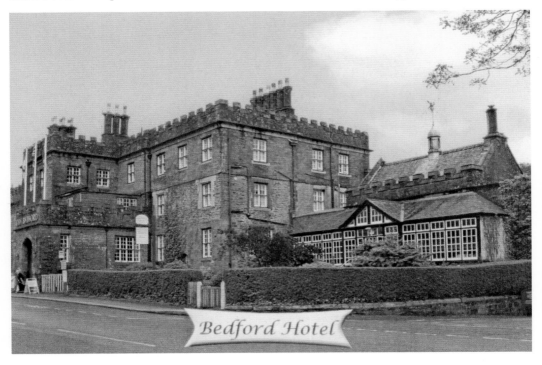

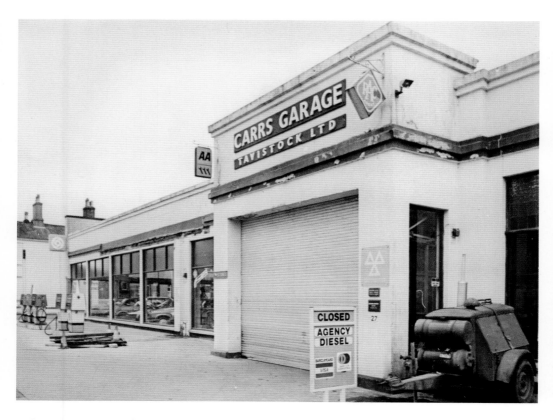

Robert Carr ran a motor business from 1923, with garages successively at Parkwood Road and Drake Road and a showroom in Duke Street. In the early 1930s the move was made to Plymouth Road, where Robert, and later sons Bob and Dennis, ran the business through until 1990. The premises are shown in the later years. The long-term successor to this substantial Plymouth Road site was the public library, which was at last liberated from the constraints of its old, increasingly cramped, premises in the market perimeter.

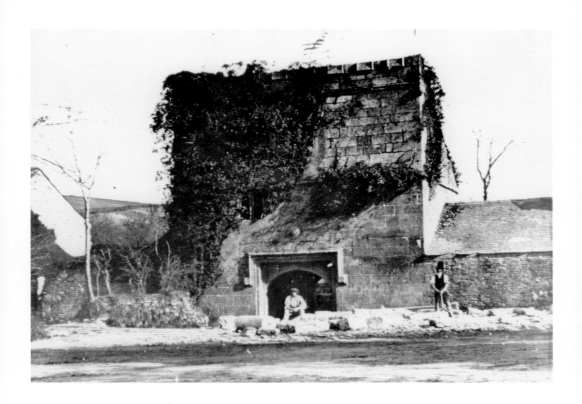

The Fitz family, one of Tavistock's most illustrious dynasties, was settled, from the fifteenth to the seventeenth centuries, in Fitzford, the mansion that combines the family name with a reference to the nearby ford, where later was to stand West Bridge. By the nineteenth century nothing survived of this great house except for the gate-house, which, as the earlier picture, taken in 1869, shows, was ripe for demolition. It was, in 1871, rebuilt on the same site. From here Lady Mary Howard, the last of the resident Fitzes, begins and ends her nightly journey of penance, a punishment for a, presumed, sinful life.

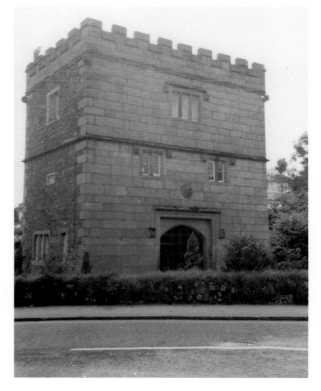

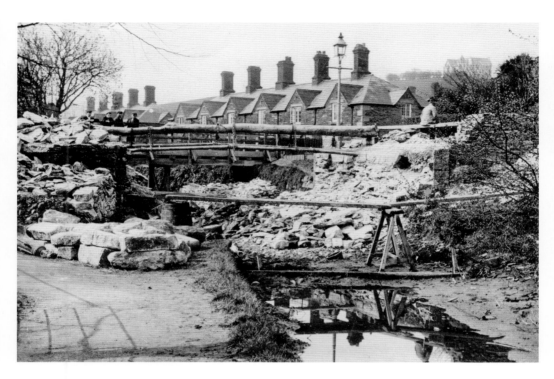

In the middle years of the nineteenth century the Duke of Bedford's Estate, as a contribution to easing the problem of the shortage of decent working-class housing, constructed 282 cottages in various parts of the parish. The 36 at Fitzford occupied an area that had once been part of the estate of the Fitzford mansion. In the older picture they are viewed in 1902 as a backcloth to the construction of a new bridge taking the Plymouth Road over the canal.

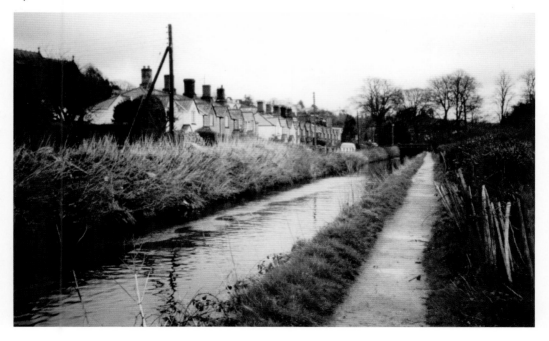

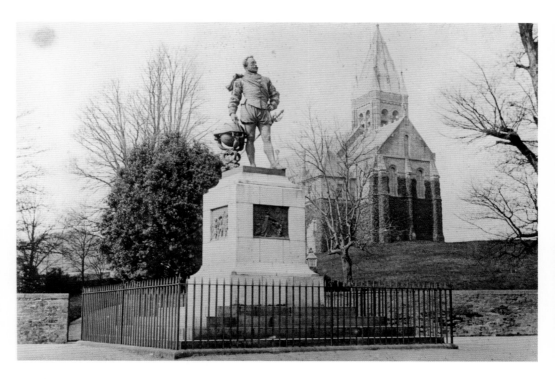

Two features that dominate the scene at Fitzford are the church and the statue. The huge Lombard-style Fitzford church was built by the Duke of Bedford in 1867 to serve a growing, and predominantly working-class, population in the western part of the town, and was, in the first years, referred to as "the miners' church". Trade depression and depopulation led to two prolonged closures before, in 1952, it was passed on to the Roman Catholic community. The Drake Statue dates from 1883. The hero, born at Crowndale, half a mile away, stands ten feet tall, on a twelve-feet high pedestal which contains three bas-reliefs depicting moments in his career.

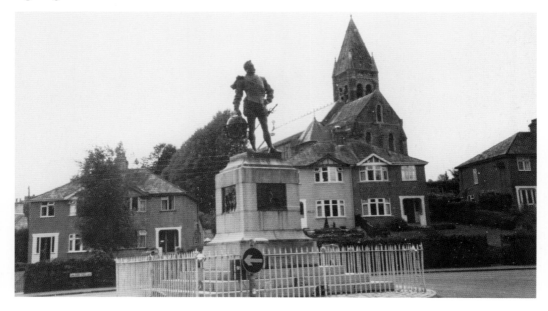

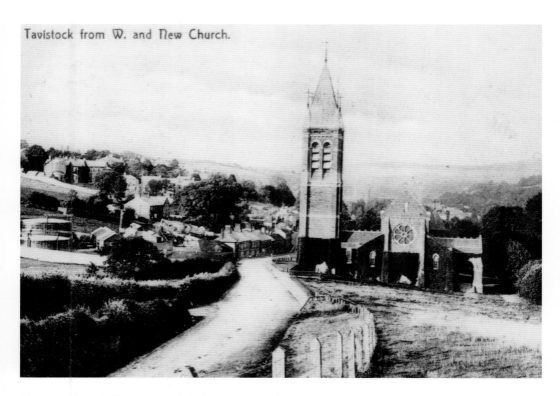

Tavistock from W. and New Church.

The view from Callington Road looking east. Fitzford church, opened in 1867 and a Roman Catholic church since 1952, is seen to dominate the area. The foot of Crease Lane is discernable. Missing from the earlier scene is the twentieth century development of Highfield. Missing from the later picture is the original gasworks. On the site shown on the left of the older picture, near the foot of what was Gas House Lane and is now Maudlin's Lane, gas was produced from 1832 to 1906.

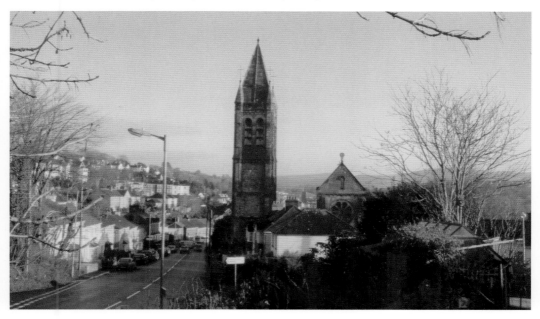

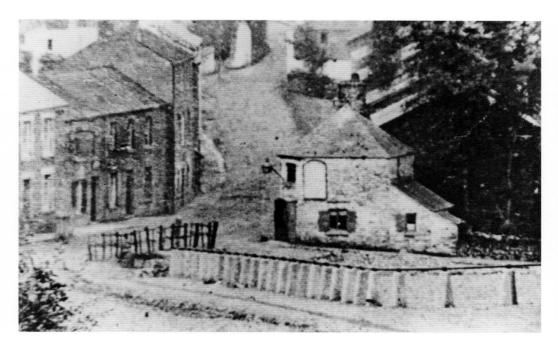

A pair of pictures that focus on the point at which Ford Street meets Callington Road. The eye-catching feature is the presence, in 1870, of a toll house at this junction. It had been built a century earlier to guard the entrance to the turnpike road to Gunnislake. Unlike some other toll houses on the edge of the town, which have survived, this one was, soon after the picture was taken, first to lose its function, and then to fall victim to modern traffic needs. Ford Street derives its name from the fact that in the medieval town it provided access to the river ford that was to be replaced, in the sixteenth century, by West Bridge.

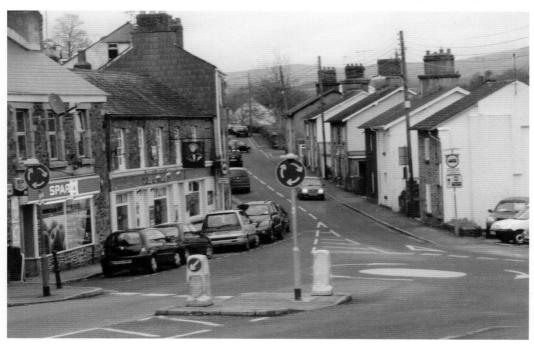

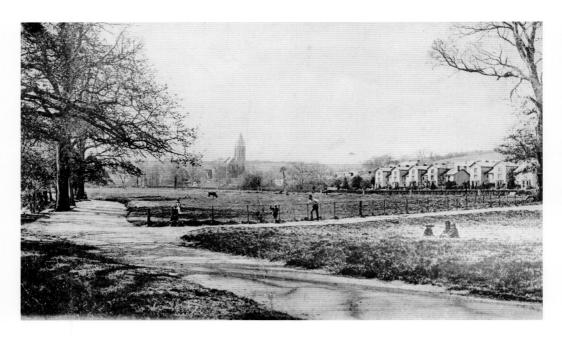

The Meadows is a substantial area of open land between Plymouth Road and the river, stretching from the Canal Wharf to Fitzford. Since time immemorial townsfolk have used it as a place in which to stroll, play, and meet. It was, however, when the first picture was taken, private property, owned by the Duke of Bedford, who let it out as a hay meadow and for grazing. A brave attempt to produce, a century on, a comparable vista met obstacles in the form of unhelpful, albeit beautiful, trees.

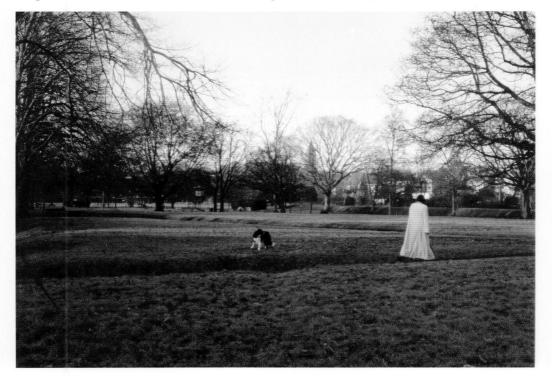

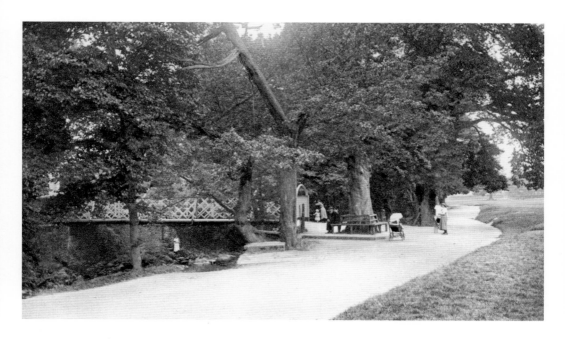

On its passage through the Meadows towards West Bridge, the Tavy provides a popular walk. Here Edwardian mothers and nannies are seen giving their charges an airing. The iron footbridge over the river had been erected in 1904, and carried a sewer. It was replaced in 2008. The refreshment kiosk is a relatively recent addition. Between the dates of the two pictures the Meadows was, in 1913, bought from the Duke of Bedford by the Urban District Council, after which it was developed to provide the amenities of a public park.

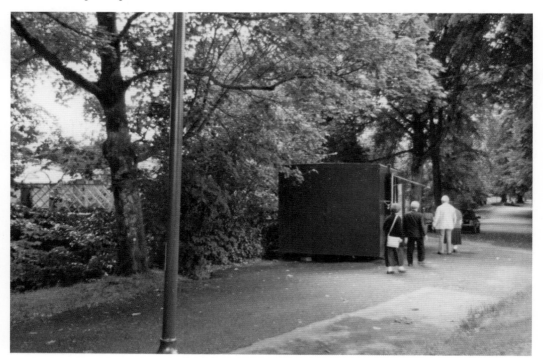

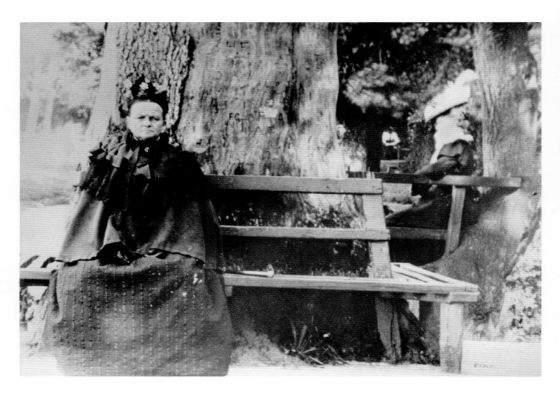

Seventy years separate these two glimpses of ladies in the Meadows. In 1899 two ladies of a certain age take a rest. In 1969 two young ladies walk to school. The severe looking Victorian lady was obviously not responsible for the initials carved into the tree-trunk. Was she also unconnected with whatever was going on behind her?

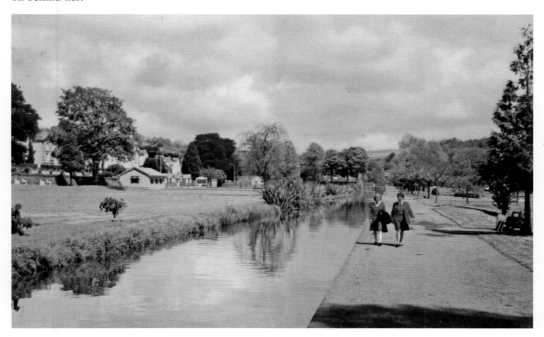

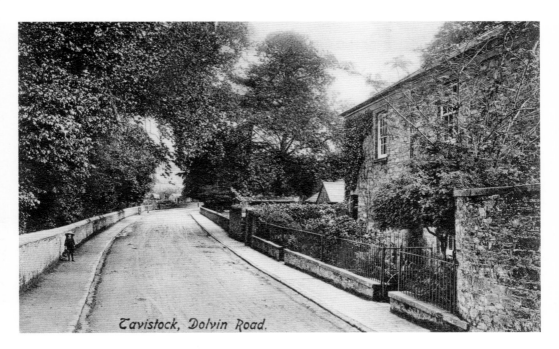

Tavistock, Dolvin Road.

Dolvin Road from Abbey Bridge. The name commemorates, in a slightly corrupted form, the Godolphin family, who owned land hereabouts. The house on the right is the long-time home of the Collacott family, who produced generations of craftsmen and pillars of the church. Beyond is the Victorian graveyard, already full when this picture was taken and superseded by the new cemetery on Plymouth Road. Completing the Victorian ambience of the street are 18 Duke of Bedford cottages and an elementary school, all built between 1845 and 1848.

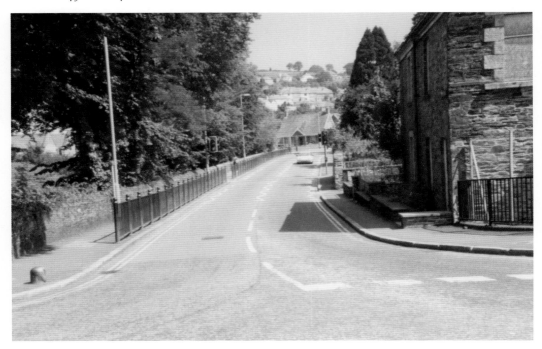

The old route from Tavistock to Plymouth, turnpiked in 1762, led though Whitchurch and crossed the River Walkham at Horrabridge. In 1822 it was superseded by a new road that left the town at West Bridge and proceeded through Grenofen and over Magpie Bridge. The old road became redundant, and remained in a neglected state for a century. It took the arrival of the motor car and modern housing developments to enable it to recover a role as a busy artery. The stretch featured is between The Priory and Hunson Villa, with the camera pointing away from Whitchurch.

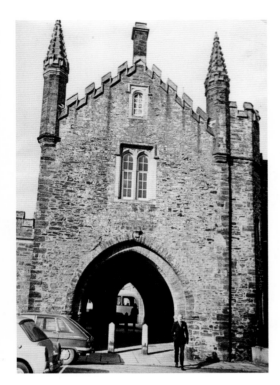

Tavistock abbey was dissolved in 1539 after a life of 565 years. The lower picture gives an idea of the extent of the abbey campus, which occupied a rectangular, enclosed site, stretching, in modern terms, from close to the parish church to the river, and from the guildhall to the vicarage. There were four entrances, the principal one being Court Gate. Shown above, it was much restored in the early nineteenth century, after which its upper floor housed the library for some years, and is now the home of the Tavistock Museum.

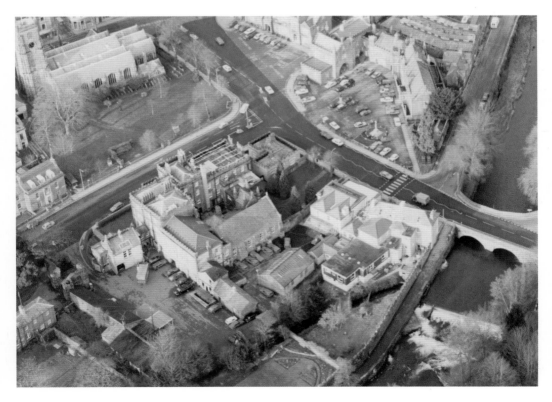

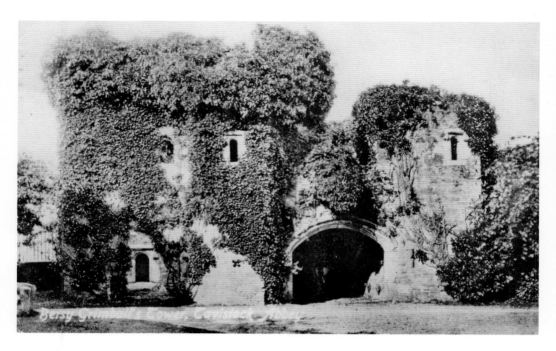

Betsy Grimbal's Tower, one of the four entrances to the site of the medieval abbey, has changed little, the haircut apart, between the dates of the two pictures. The monastic remains are not extensive, and this ruined building is one of the few potent reminders of an institution that flourished for five and a half centuries. But who was Betsy Grimbal? Not the hapless victim of a murder, as local folk-lore would have it. The commemoration is of the Blessed Grimbald, a ninth-century saint much revered by the Benedictine Order.

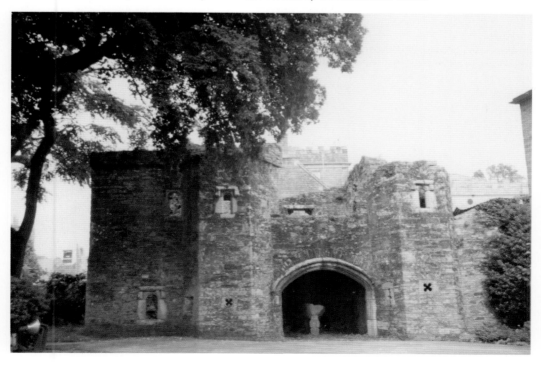

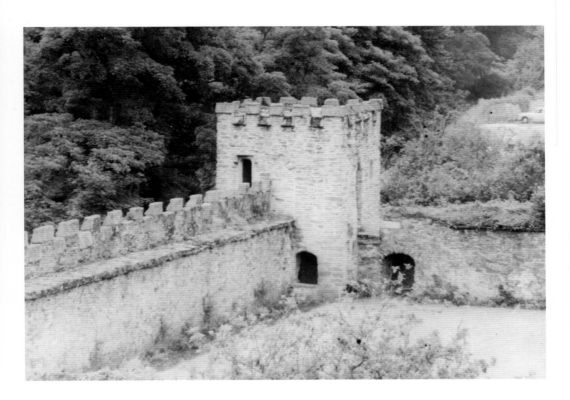

Marking the south-west corner of the precinct of Tavistock abbey, and close to the right bank of the Tavy, stands the monastic still tower, in which generations of monks prepared their medicines and potions. The lower picture, of recent date, is taken from the riverside walk below Abbey Bridge. The upper picture, taken about fifty years ago, gives a view from the opposite angle. The tower forms part of the vicarage garden.

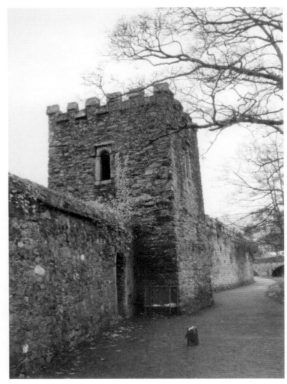

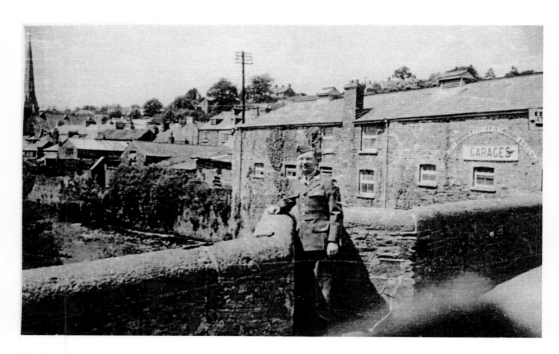

The highest of the three road-bridges across the Tavy in Tavistock before the construction of Stannary Bridge in 1995 was Vigo Bridge. Built in 1773 to launch the new turnpike road across the centre of Dartmoor, its name derives from some nearby property. This may, in turn, have commemorated one of Drake's daring expeditions, but is more likely to have related to the more recent battle of Vigo Bay, in 1702. In 1944 Sgt Arthur Riedesel, United States Army, was pictured here enjoying a peaceful afternoon and, no doubt, wondering when he and his comrades would be given the green light to launch the invasion of Europe.

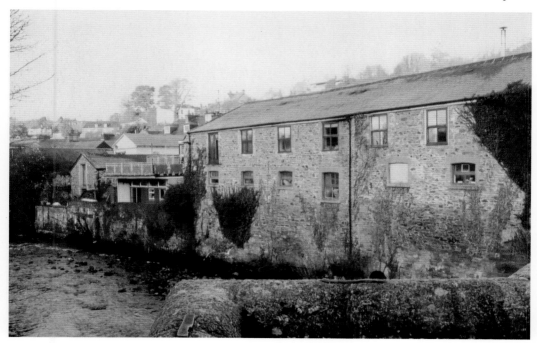

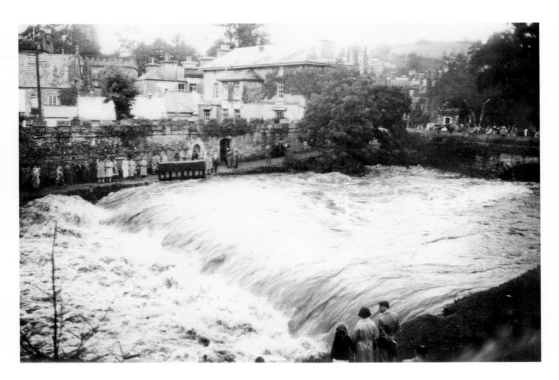

Abbey Bridge is the third, and most central, of the four bridges crossing the Tavy in Tavistock. Constructed in 1762 to serve the turnpike road to Plymouth, it was widened in 1860 to cope with the traffic to and from the newly opened GWR station just across the river. The recent picture shows also the source of the canal, the weir, and the river in benign mood. The 1930s scene has attracted crowds onto the bridge and onto both sides of the river, to be reminded that 'Mother Tavy' occasionally throws a tantrum.

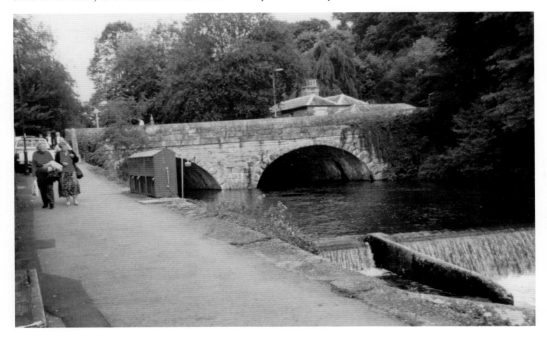

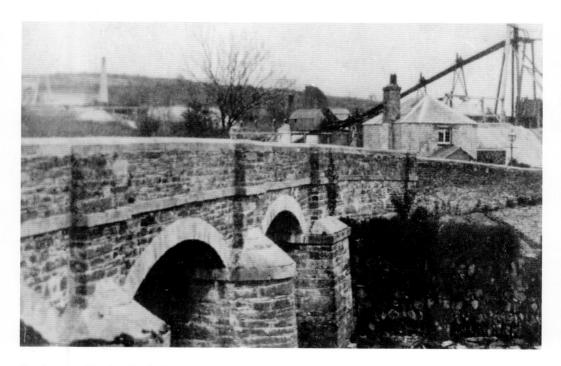

The lowest of Tavistock's bridges, West Bridge, was constructed on the site of a ford in the middle of the sixteenth century. The old bridge is shown here (above) in a picture that also affords a glimpse of Wheal Crelake, the copper mine nearest to the town centre. In 1940 the bridge was replaced by the single-span bridge that now carries the main road to Plymouth. The modern bridge is shown below, as are also the surviving foundations of the temporary bridge that did service during the work of replacement.

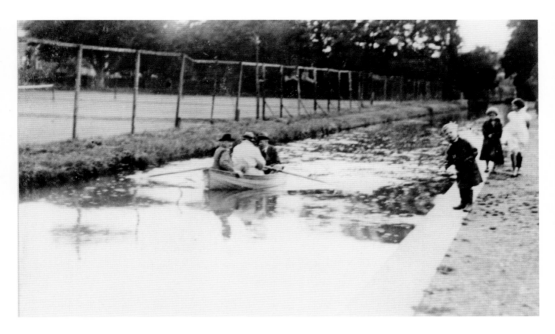

The four and a half mile Tavistock Canal was constructed in the early years of the nineteenth century to link Tavistock, the centre of a prosperous copper mining area, with Morwellham on the Tamar, the nearest navigable port. It had a productive life of half a century before falling to the competition of the railways in the 1860s. It now has a limited function in powering a generating station at Morwellham. There have been occasional recreational uses, as the 1934 photograph illustrates (taken on August Bank Holiday Monday, hence the weather). The colour picture is a contemporary view of the Canal Wharf, with its unmistakeable warehouse buildings.

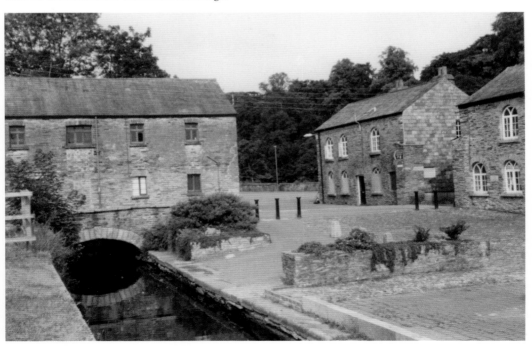

The demise of the Tavistock Canal in the 1860s left the Wharf a backwater. Where once had been activity, bustle and noise, there was now an air of abandoned dereliction. Some of the redundant buildings were adopted by tradesmen and organisations and some were used by the local council for storage purposes. But some fell into disuse. From the ashes of one such storehouse rose an arts and entertainment centre that opened in 1995. Retaining the name "The Wharf", the transformation may be glimpsed in the two "before and after" pictures.

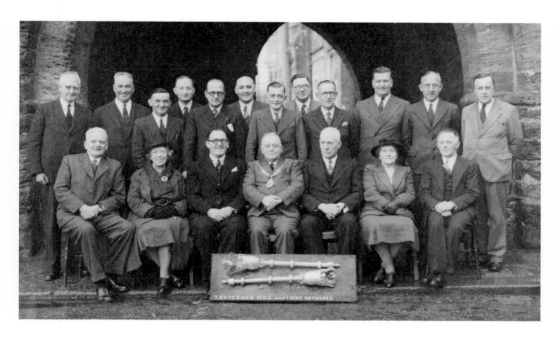

In 1948, to mark the golden jubilee of the Tavistock Urban District Council, members and officials gathered for the camera. Left to right — standing: Messrs Pethick, Willis, Moore, Colson, Reeve, Lowe, Tovey, Allen-Price, Lacey, Goode, Rawling, Quant. Sitting: Messrs and Mesdames Kerswill, Johnstone, Jenkins (clerk), Heyden, Pearce, Bazley, Knott. Fifty years on, in 1998, the line-up is, left to right- Standing: Messrs and Mesdames Williams, Masters, Gorbutt, Brace, Pike, Corner, Mathew, Johnson, Sherrell, Howard (clerk). Sitting : Messrs and Mesdames Batchelor, Smith, Wright, Woodcock, Sanders.

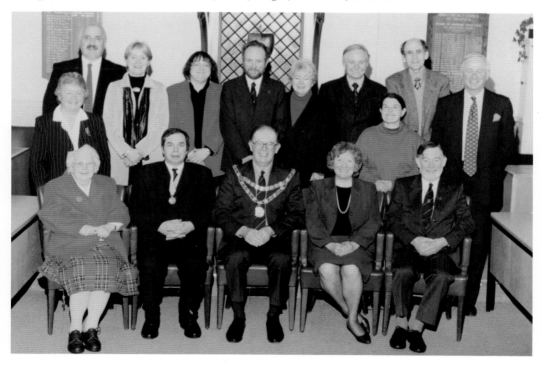

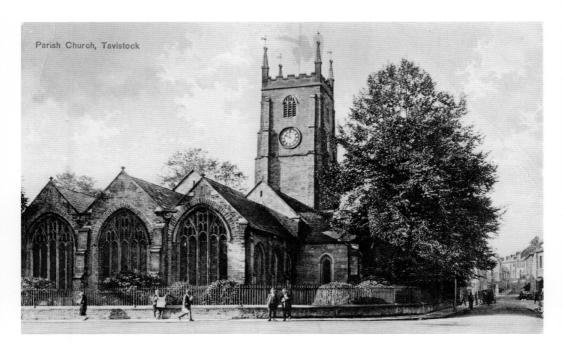

Parish Church, Tavistock

The parish church of St. Eustachius was dedicated on 21 May 1318. Among later changes was the addition, in 1445, of the Clothworkers' Aisle, a feature that served to emphasise the importance of the woollen industry to the economy of the medieval town. The two pictures show no architectural changes over the century, the main alterations being to trees and railings. The lower half of West Street is glimpsed on the right. Where taxis now lurk was once a favourite place to meet, and, perhaps, to read the newspaper while you waited for *her* to turn up.

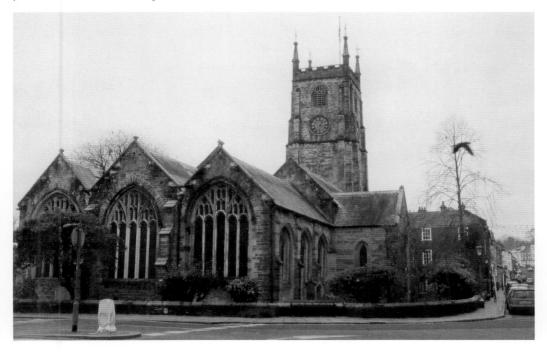

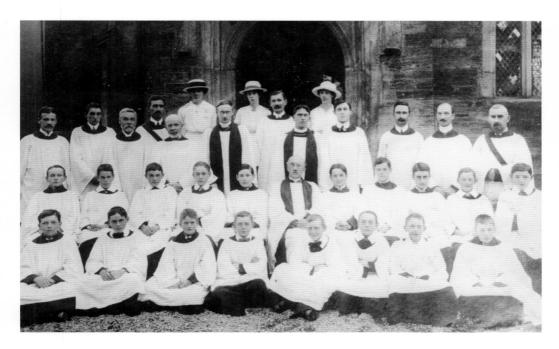

The choral tradition at St. Eustachius's is a long and strong one. The modern choir, for many years under the direction of Pearce Richards (on the right), made a number of broadcasts and recordings, and are shown here at one of their Christmas celebrations. The upper picture shows the choir in 1914, with the Vicar, Henry le Neveu, centrally seated. Immediately behind him is one of his curates, John Pim, and, alongside, the other curate, Hugh Bickersteth. Rev Bickersteth was to succeed as vicar when Rev le Neveu died in 1918.

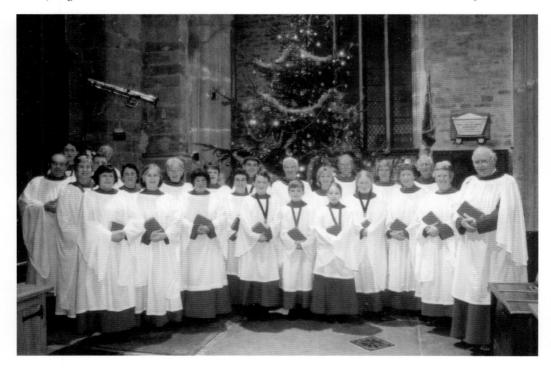

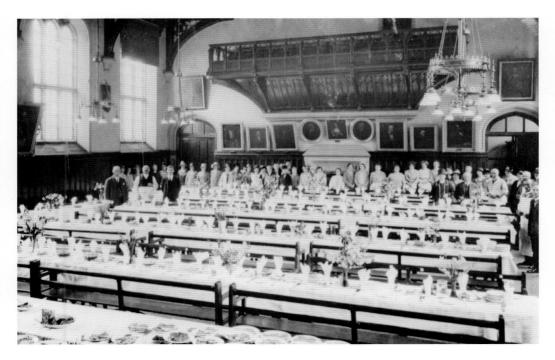

John Wesley records, in his Journal, five visits to Tavistock. The present Methodist chapel, opened in 1857, replaced an earlier one in Barley Market Street. The nineteenth century saw divisions within the family and by the mid-century there were three Methodist congregations meeting in the town. The 1857 Chapel was Wesleyan, but is now the home of a united Methodist church. The upper picture was taken in the town hall in 1925, and records the occasion of members attending a Methodist regional conference taking a lunch break between meetings.

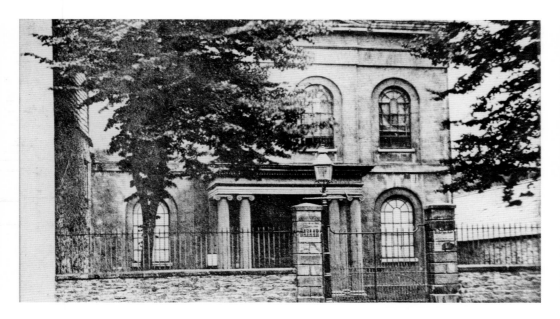

The first dissenting congregation in Tavistock, formed in the last years of the seventeenth century, met in the abbey chapel. A hundred years later there was a schism, and the more moderate element, the Congregationalists, left their more radical fellows, the Unitarians, and established themselves in Duke Street. In 1820, however, their chapel burned down, and was replaced by the chapel in the first picture, which occupied a site that was, much later, to welcome Woolworth's. This building, in turn, gave way to an impressive, spired church across the road, which was demolished in the 1960s. At this point the Congregationalists, following a national union with the Presbyterian Church, moved to the Russell Street Chapel (below), as members of the United Reformed Church.

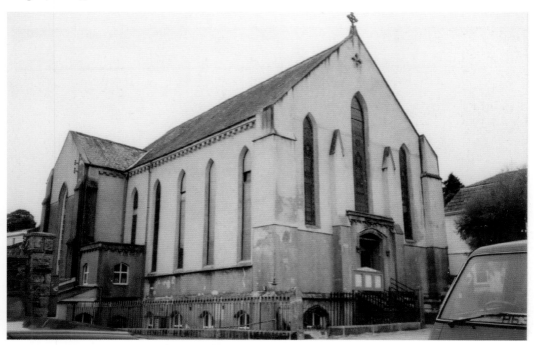

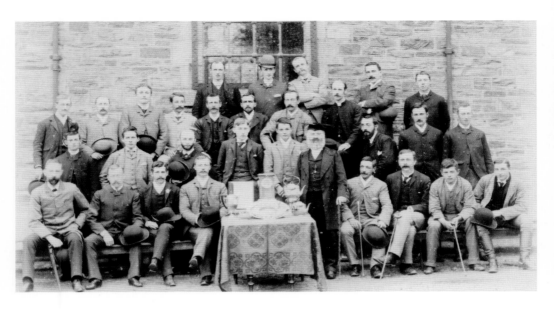

The grammar school on the corner of Plymouth Road and Russell Street was opened in 1837, among its earliest pupils being W H Smith. Its longest serving headmaster, for thirty-five years, was Rev Edward Spencer, who retired in 1888, in his seventieth year. The occasion was marked by a gathering of Boys and Old Boys, and the presentation of "a silver tea and coffee set, a richly chased and engraved silver salver, and a handsome timepiece under a glass shade". The fine building, having been superseded by a new building further along Plymouth Road, experienced periods as a doctor's surgery and a private school before entering its present, residential, stage.

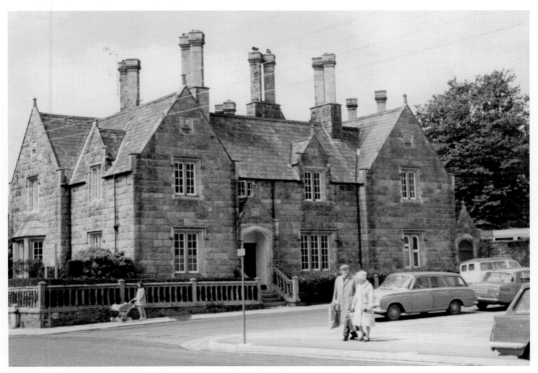

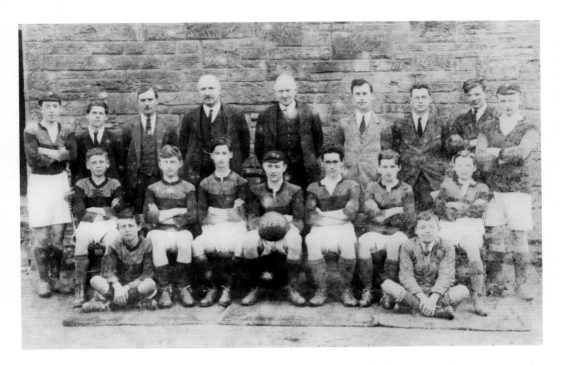

The Russell Street Grammar School was closed by the Duke of Bedford in 1888, and a new enterprise was launched further along Plymouth Road in 1895. For nearly all its 37 years as a grammar school this establishment was headed by J. J. Alexander, and it is appropriate that, in its modern incarnation as a centre for adult learning, it should be known as "The Alexander Centre". The 1925 picture shows "J J" with the school's football team, and flanked by his staff of four: left to right, C. Hartley, E. W. Wallis, R. C. Sleep, and H. A. Davies. To the boys they were 'Froggy', 'Joey', 'Sleepy', and 'Taffy'. Alexander was 'Junket'.

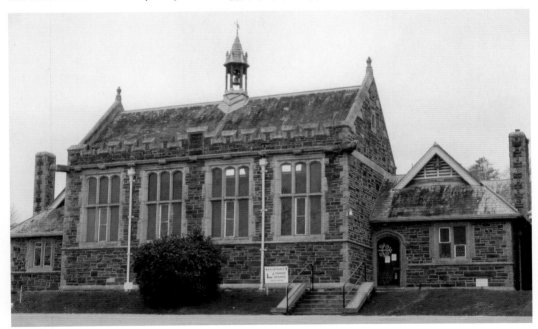

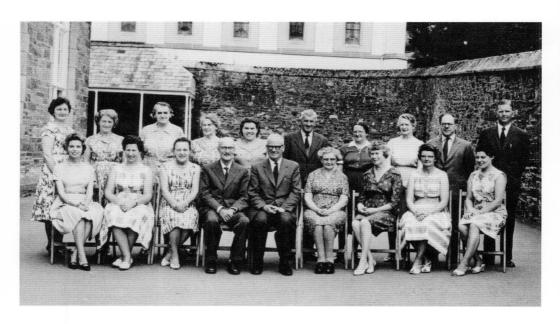

At four o'clock on the afternoon of Saturday 19 July 1856 a large crowd gathered in Plymouth Road to welcome a former Prime Minister, Lord John Russell, brother of the Duke of Bedford, who was to formally open one of the Duke's gifts to the town, a new elementary school. The school was to change its title a number of times during the 135 years of its residence before, as a county primary school, it out-grew and vacated the premises, which were then transformed into the Abbey Surgery. Above: Headmaster Norman Bucknell and the staff in 1963. Below: a mayoral reception for the school's winning six-a-side football team, with teachers Lionel Sims and Michael McKnight, in 1982.

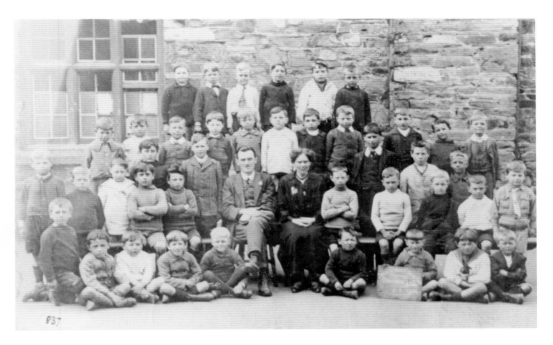

In 1847 the Church of England authorities opened a school on Dolvin Road. Originally an all-age elementary school, it has gone through a number of transformations, and is now an infants' school. The church connection remains. One of the best-remembered Heads is A. B. Treloar, who ruled the school from 1920 to 1946. He appears here with some of his pupils. The board reads: "Dolvin Road Boys' School. Standards 1 and 2. 31.3.1920." The line-up of staff in 2007 reads, left to right – standing: Mesdames C. Wesson (head), R. Warnett, M. O'Boyle, S. Gawman. Sitting : Mesdames M. Traber, C. Giadrini, S. Weatherhead, J. Frost, H. Chidgey, K. Hoare. Mr I. Carter is given pole position.

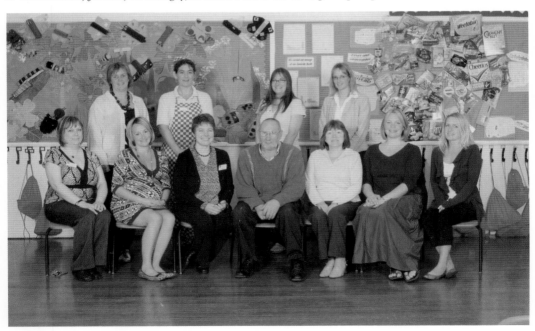

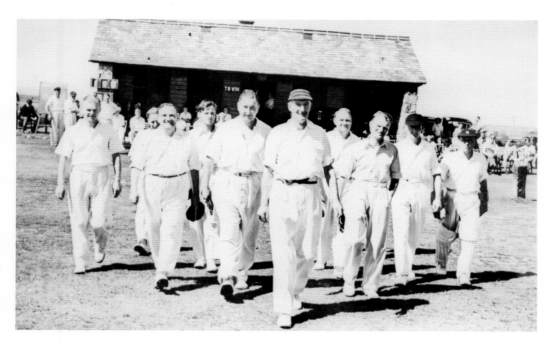

For much of their history the town's cricket and football clubs have had permanent homes. The Cricket Club has played at The Ring since its formation in 1849, and is seen here coming out to field in its centenary fixture. Left to right: D. Treloar, E. Stockbridge, M. Avery, D. Gordon, E. Davey, G. Parry (captain), J. Wedd, S. Colling, R. Forbes, W. Elderton. Hidden: F. Millman. The Football Club has played at Langsford Park since 1947. Its 1997 Golden Jubilee line-up is, left to right – standing : P. Lowe, J. Dawe, D. Babb, N. Minhinnick, D. Symons, A. Brenton, S. Shaw, A. Godfrey, C. Gott, D. Halfyard, L. Newton, E. Pinch. Seated : J. Hajigiana, R. Campbell, S. Metters, R. Fenner, J. Collins, M. Wall, T. Bason.

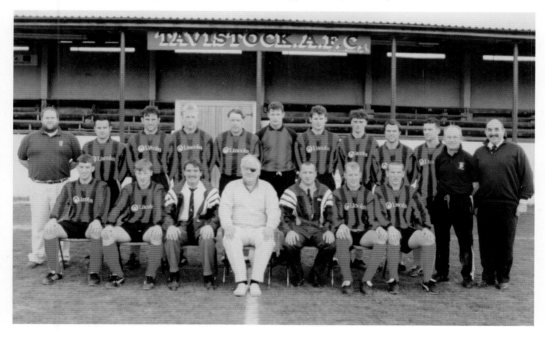

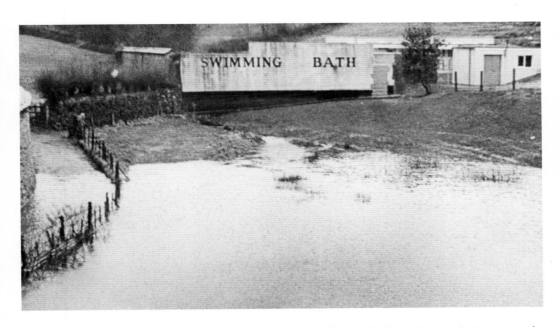

In the same month in the middle of 1883 that saw the unveiling of the Drake Statue, the Portreeve, the town's highest public dignitary, had another opening ceremony to perform, and the Duke had another bill to pay. The town's new swimming bath was opened, above Bannawell Street. Season tickets, from April to October, were to cost three shillings (15p). Men and boys could use the pool in the morning and the evening, and ladies in the afternoon. With occasional rule amendments the pool was to survive through to 1989, when it was replaced by the Meadowlands Leisure Pool.

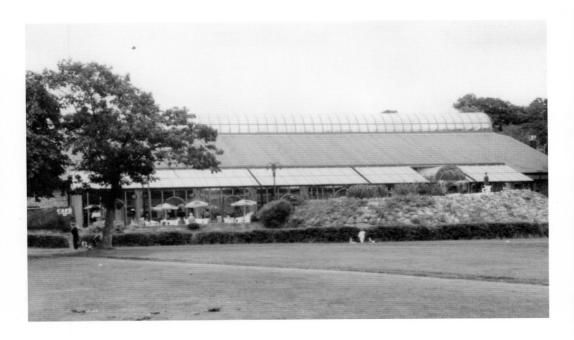

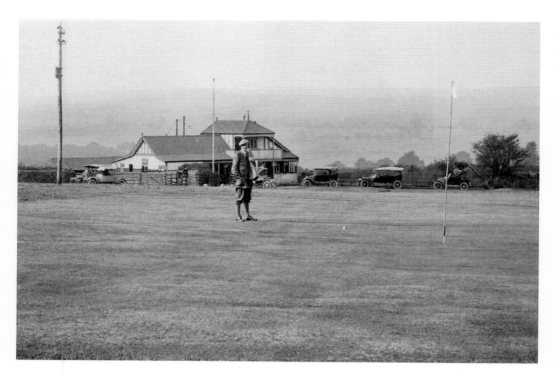

In 1905 the golf club built a new clubhouse to replace the accommodation that had been built when the club was founded in the previous decade. The 1905 clubhouse, shown above, occupied a site on the opposite side of Down Road to the present building. The latter was built in 1915, and survives, albeit with major extensions. The lone Edwardian plus-foured member is unknown. Not so his 2008 counterpart, who is Mr Kevin Parris.

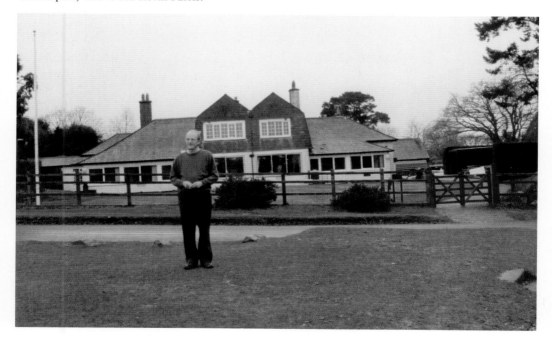

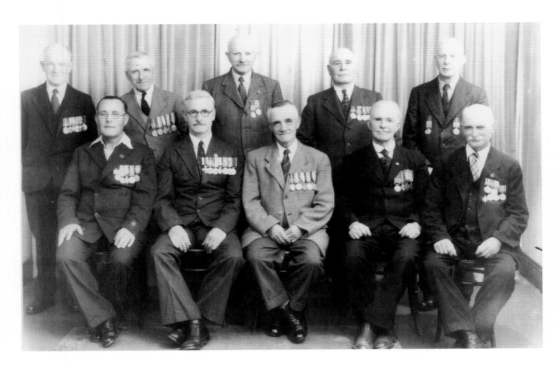

In the late 1940s ten survivors of the Boer War Veterans' Association met for the last time. Billy Young, the association's founder, sits fourth from the left, with his brother Frankie standing behind him. Messrs McGahey and Godfrey, residents of Parkwood Road, stand far left and far right. Centrally, Mr McCabe of Bannawell Street sits and Mr Jeffrey, steward of the West Devon Club, stands. Sitting on the far left is renowned trombone player Mr Lawrence. The Dunkirk Veterans, recalling more recent events, are seen in 1982 leaving the Parish Church after a service of commemoration.

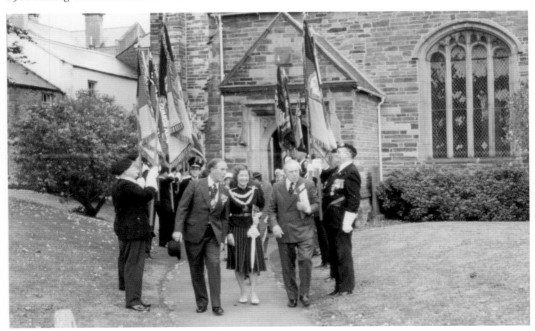

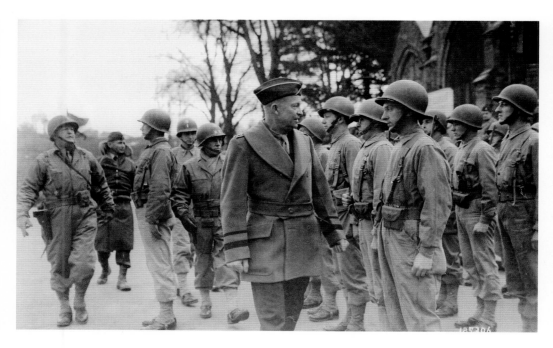

D Day memories. On 4 February 1944 the Supreme Commander of the Allied Forces, General Dwight D Eisenhower, inspected an infantry unit in Tavistock's Bedford Square as part of a visit in which he conferred, in Abbotsfield Hall, with Field Marshall Montgomery. Also on parade are General Omar Bradley, and, second from the left, Air Marshall Sir Arthur Tedder. The invasion of Normandy, that followed four months later, took its toll of American and British lives, including, as the war memorial records, the life of Trooper Leslie Holwill of Tavistock.

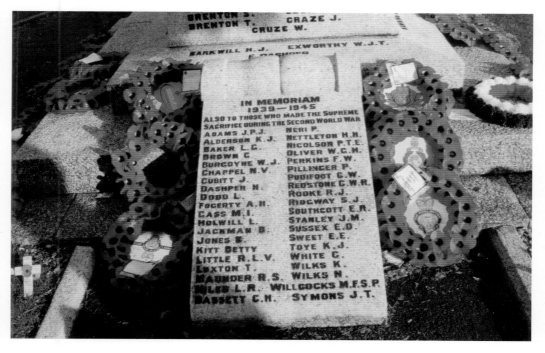

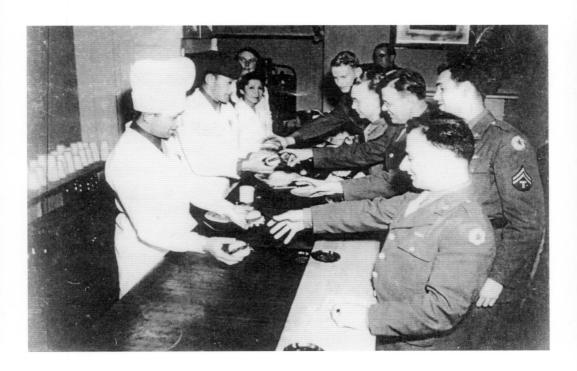

GI memories. Lynbridge House, on West Street, now a dentist's surgery, was the club for the American forces stationed hereabouts from 1943 to 1944. Here, on October 1st 1943, hamburgers are being served to, left to right, Sgt John Clark, Sgt Arthur Riedesel, Sgt-Maj Bill White, Corp Raymond Emery, and Pte Tony Eva. A year later Corporal Emery married Patricia Horrell of Tavistock, who thus became one of the 42 Tavistock GI brides. Another was Barbara Bickle, whose husband, former GI Eddie Allen, died in 1977. Barbara is seen presenting to Tavistock Mayor John Philpott the flag that had covered Eddie's coffin.

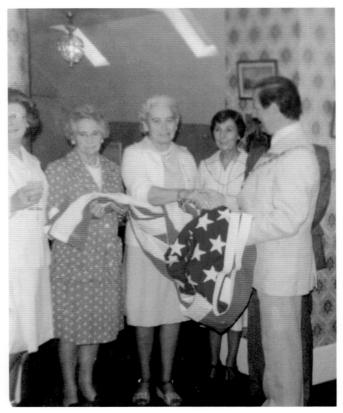

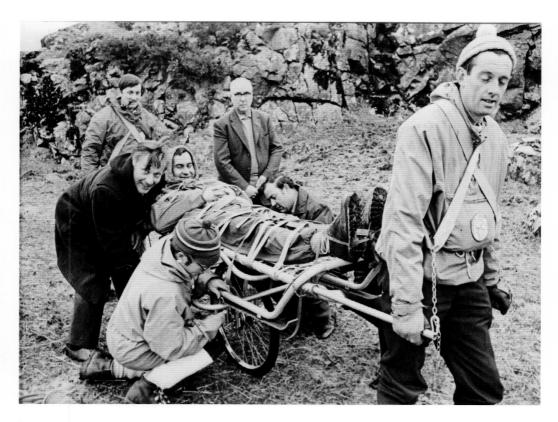

The Dartmoor Rescue Group was established in 1969, with Tavistock housing one of its four moorside bases. Alan Grundy, the editor of the *Tavistock Times*, is the "casualty" in the early exercise. Thirty years on the group poses with civic dignitaries. Present on both occasions is stalwart Bill Ames.

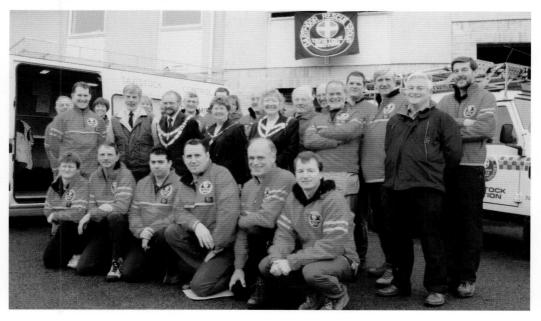

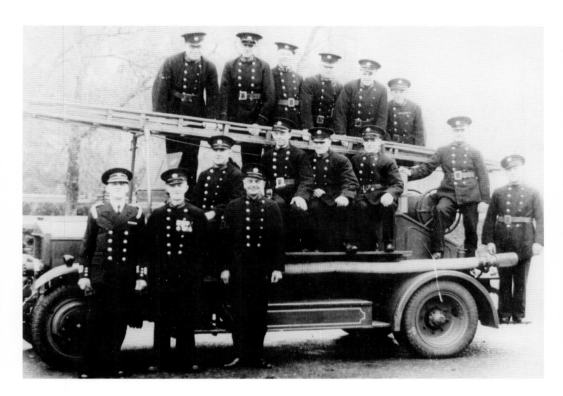

The Fire Brigade. Above – 1939: James Acton, the new chief, stands front left, alongside Jack Collacott and Bill Palmer. Left to right – back row: Jack Walters, Robert Kelly, Roy Acton, Russ Sloman, Ted Hutchins, Frank Burgoyne. Middle Row: Tom Craze sen., Jack Knott, Robert Stanbury, Fred Stephens, Cyril Simmons, Tom Craze jun. Below – 2005: Left to right – Standing : Stuart Sealey, Doug Craze, John Matthews, Penny Symons, Phil Griffiths, Ross Glover, Mark Dyson, James Philpots, Terry Cundy, Chris Hicks, Ian Smith, Danny Delaney, Charlie Cruise, Akimor Ali. Sitting: Mark Tugwell, Dave Valentine, Mitch Kingham, Rob Turnock, Jim Sherrell, Tim Smith, Glen Arundel, Simon Smith, Keith Lake, Tony Savage, Terry Lowe.

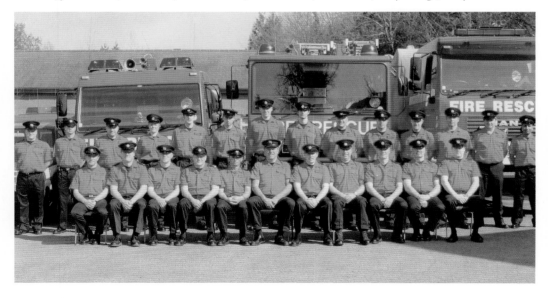

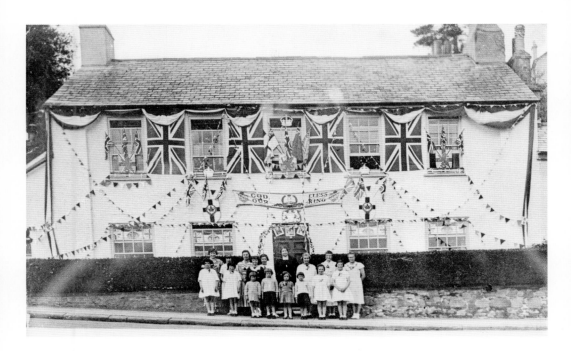

In 1887 Daniel Radford of Mount Tavy bought No 33 West Street, a substantial house nestling at the foot of Spring Hill, and, in order to commemorate Queen Victoria's Golden Jubilee, presented it, suitably adapted, as the town's first hospital. It was superseded, nine years later, by a larger building up the hill. The next public function for No 33 was to house, from 1913 until after the Second World War, a "scattered home", or orphanage, first for girls and later for boys. The residents in 1937 are seen celebrating the coronation of George VI, the building now houses a dental practice.

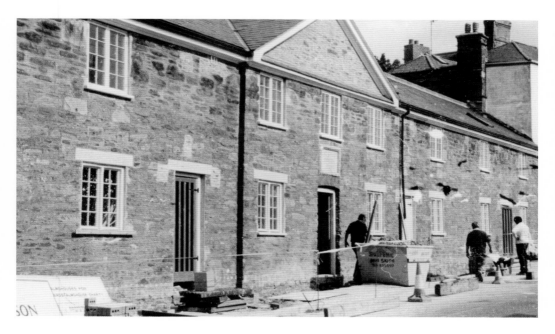

The Old and the Young. In 1763 the Ford Street Charity was established by amalgamating a number of gifts made over the years. It built an almshouse to accommodate fifty elderly and needy parishioners. In the 1870s an older charity, associated with the name of Oliver Maynard, erected an almshouse next door in Ford Street. The two charities combined in 1983, and now, following major renovations in 1988, shown here, they together offer ten flats. The youth centre, in Chapel Street, was opened in 1967, photographed in 1991, closed in 1993, and demolished in 1994.

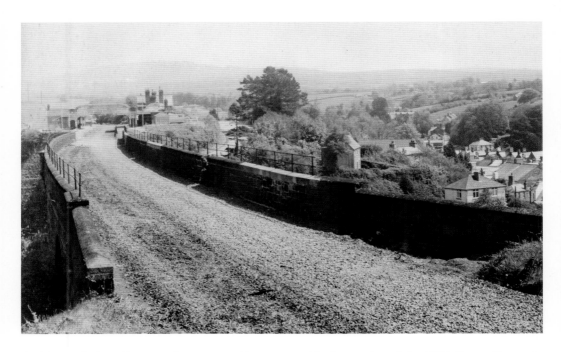

For Tavistock the railway age began on 21 June 1859, with the opening of the GWR line to Plymouth, and ended on 5 May 1968, when the last train left Tavistock North Station. The views, taken from the western end of the viaduct and looking towards the site of the Tavistock North Station, show the scene in 1970 and 2000. Above: The track has gone but the station buildings and the footbridge remain. Below: The viaduct has been developed as a part of a walkway and cycle track. A residential development, Quant Park, obscures, and partly occupies, the station site.

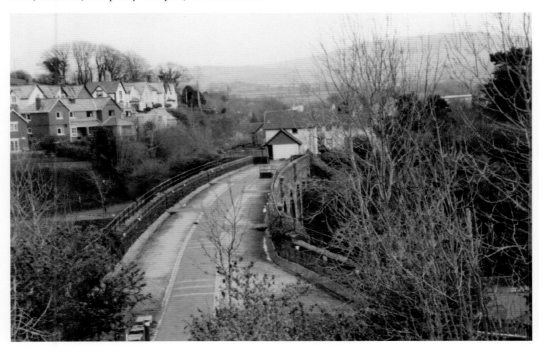

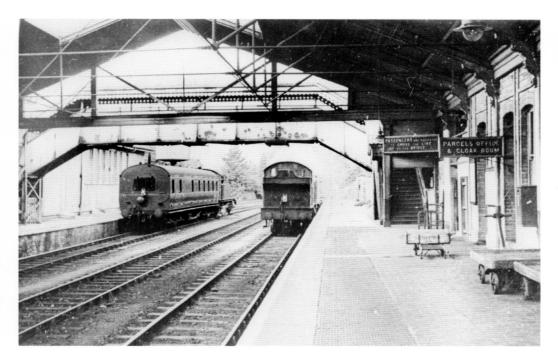

The GWR station, later relabelled Tavistock South, served Tavistock from 1859 to 1963. The original wooden station burned down in 1887 and was rebuilt in stone. In 1889 some 2000 people gathered here to hear Mr Gladstone make a brief speech from the open window of his carriage as his train passed on its way to Plymouth. The site now houses the Social Services Department, the Stannary Surgery, the Fire and Ambulance Services, and the Dartmoor Rescue Group.

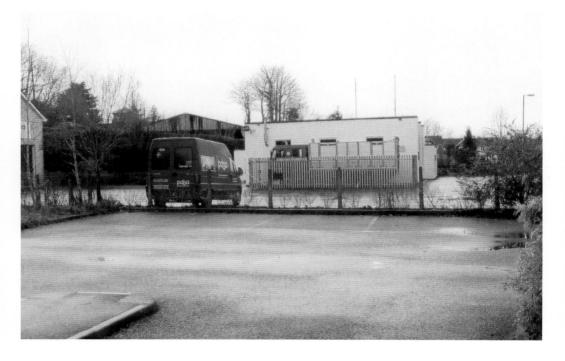

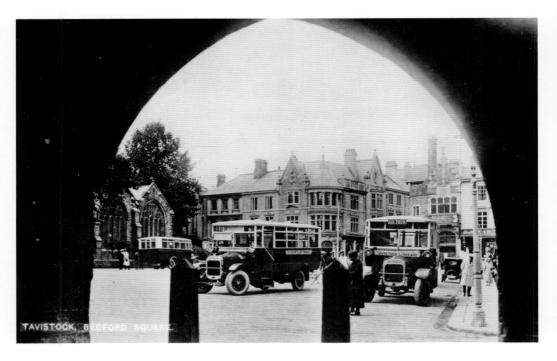

Between the wars the appearance of the motor bus meant that the railways faced competition for local public transport services. In the 1920s, as the camera observed through Court Gate, Bedford Square became a bus terminus. Towards the end of that decade the Western National Company was formed by the amalgamation of two older concerns. A project promoted by the company and the County Council reached fruition in 1958, when the bus station on Plymouth Road was opened. Below: March 1988, and the opening of a new service with the arrival, in the bus station, of the first Plymouth City bus.

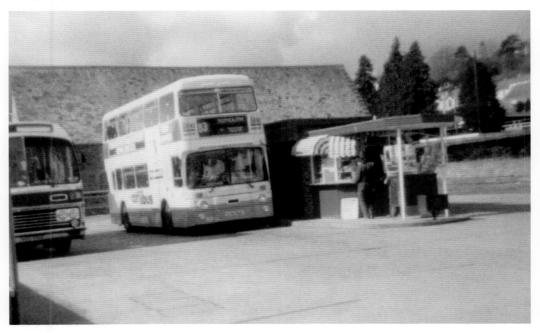

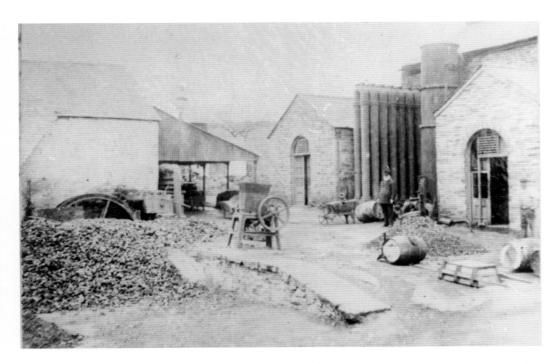

An older generation of Tavistock folk still call it Gas House Lane. The narrow, steep way that has its foot where Ford Street and Callington Road meet is now, officially Maudlin's Lane. From here, between 1832 and 1906, the town was supplied with gas (above). In 1906 the gas company opened new premises at the foot of Pixon Lane, and production at this plant continued through until 1956. Thereafter the Pixon Lane site housed, for some years, an abattoir. The gas holder was not demolished until 1990, shortly after the picture below was taken.

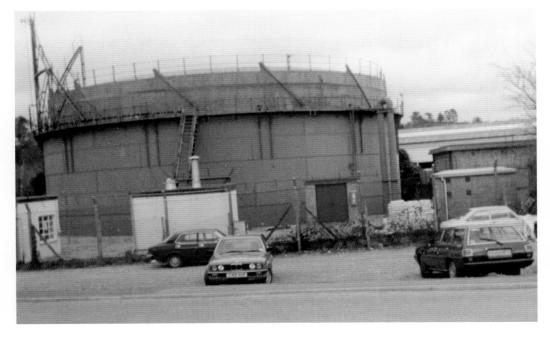

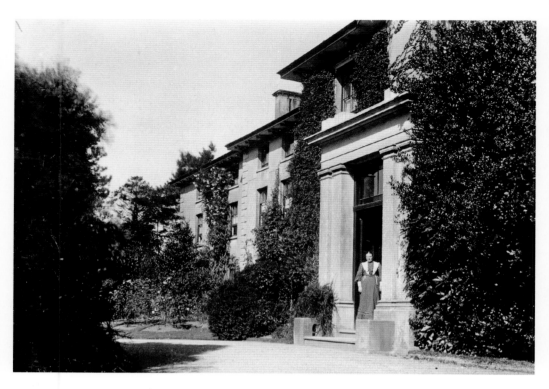

Abbotsfield Hall was built in 1852 as a suitable residence for Thomas Morris, the managing director of the company that owned the fabulously productive Devon Great Consols Mine. One of his regular visitors was his nephew William, the great designer, who designed one of the windows in St Eustachius's. After Thomas's death in 1885 the house changed hands a number of times, but was during the Second World War requisitioned by the military authorities. It was the setting for a pre D Day meeting between Eisenhower and Montgomery. After the war it became a youth hostel, before beginning a new life as a residential home.

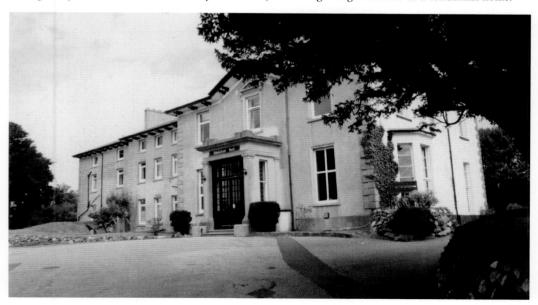

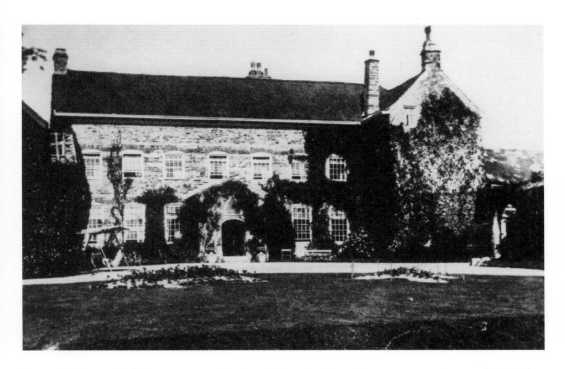

Two miles due south of the town centre lies, in seclusion, the sixteenth-century manor-house of Walreddon. It served an original purpose as a dower-house to the Fitz mansion a mile away. It was in the ownership of the Courtenay family, who became Earls of Devon, from 1671 to 1953. Among illustrious residents have been Edward Eyre, explorer and colonial administrator, Archie Jack, Olympian and war hero, and Hugh Hudson, film director and Oscar winner.

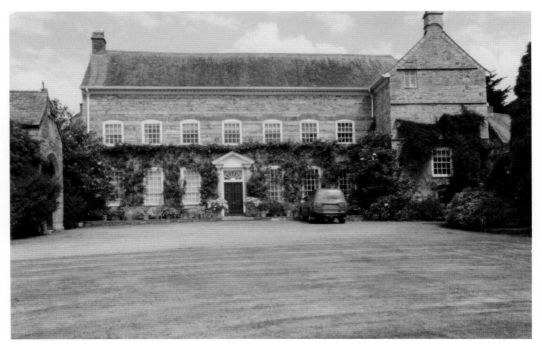

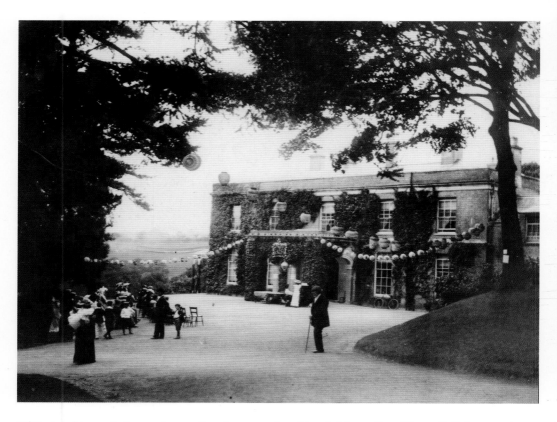

Of Tavistock's stately homes the stateliest, in terms of position, is Mount Tavy House. Built in 1800, it was the home of the Carpenter family until 1886. In 1940 John Wedd, the headmaster of a Plymouth prep school, evacuated his boys and moved the school to Tavistock, buying Mount Tavy House. It has been a school ever since. Above: a musical occasion in front of the house to mark the coronation of George V in 1911.

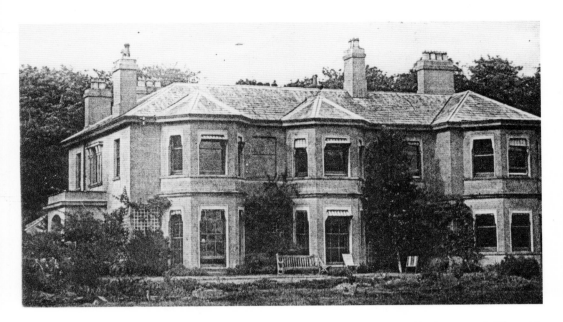

The Manor House was built in 1823 as a suitable residence for the Duke of Bedford's steward. When this official was relocated to a house at Deerpark the Manor House passed through various hands until the 1980s, when it began a slow decline into dereliction. At the turn of the century it was demolished, and the site was prepared for redevelopment. The estate that emerged retained the name "Manor", as the page of George Wimpey's 2009 brochure confirms. The older picture dates from 1954.

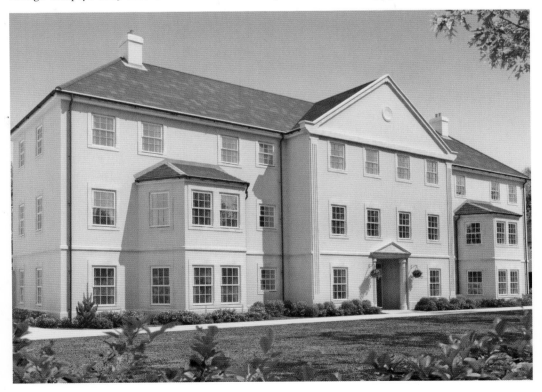

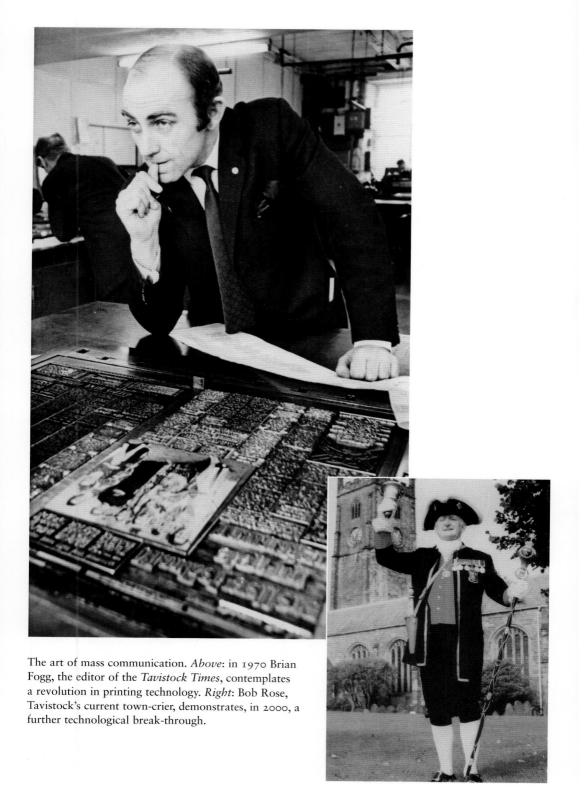

The art of mass communication. *Above*: in 1970 Brian Fogg, the editor of the *Tavistock Times*, contemplates a revolution in printing technology. *Right*: Bob Rose, Tavistock's current town-crier, demonstrates, in 2000, a further technological break-through.

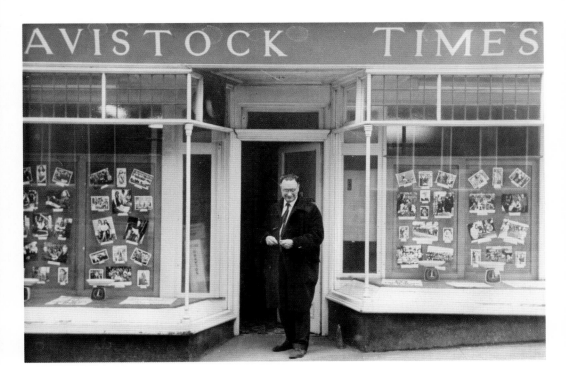

Two men have, over a combined period of forty years, shown Tavistock to itself. They are press photographers Jim Thorington and James Bird. Jim stands outside the *Tavistock Times* office, which in 1972, when this picture was taken, was in Drake Road. James, in 2008, stands on the steps of the present office in Brook Street.

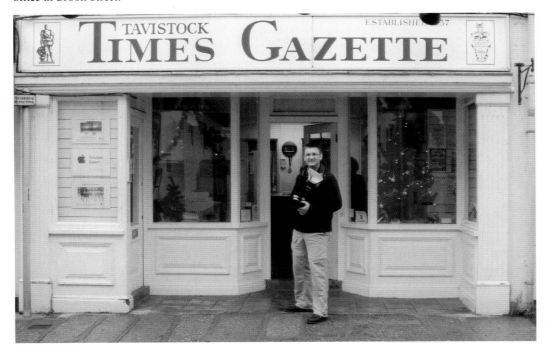

It's carnival time. In the 1921 carnival the winner in the section promoting the town's trades was the carriage fitted out as a blacksmith's shop. The blacksmith, F W Redstone, stands by his apprentice, James Acton, who holds the cup. They have borrowed the cart from Charles Green, the coal merchant. The trio celebrate their victory in Market Road, where the procession ended. In 1989 the star attraction was Stumbles, the steamroller, popular as a prize exhibit in the Meadows.

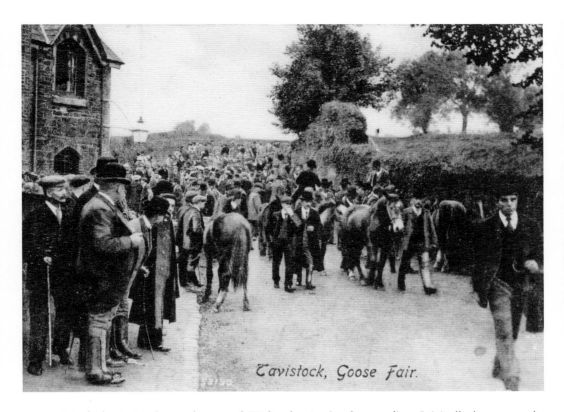

Goose Fair finds Tavistock, on the second Wednesday in October, en fête. Originally known as the Michaelmas Fair, it dates from 1552. The picture above shows the crowds in 1908 going to, or away from, the fair. The scene is Whitchurch Road, with the Cattle Market Inn on the left and the busy cattle market just beyond. Geese have, in recent years, become something of a rarity at the fair, but the appeal of the occasion, to residents and visitors, stays undimmed.

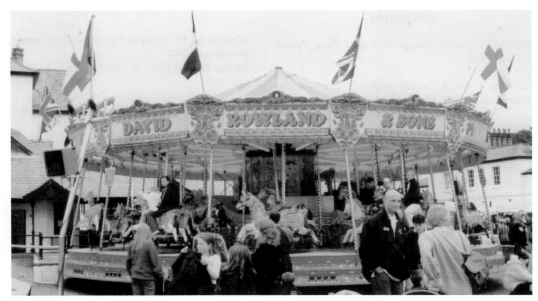

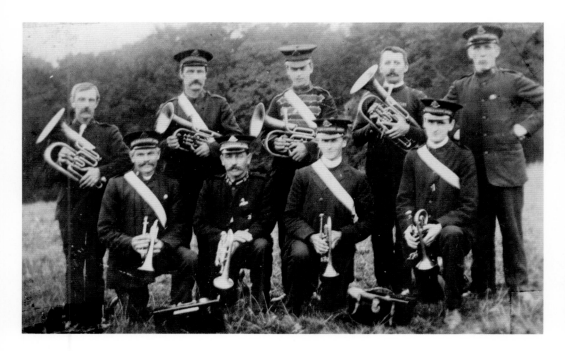

The best known band in Tavistock today is the Stannary Brass Band. Its musical director since 2000, Peter Jones, stands on the left as the band appears in Bedford Square. In 1912 the most popular music-makers were the members of the Salvation Army Band. Left to right – standing: W. Stephens, J. Smale, W. Smale, W. Friend, H. Warren. Kneeling: F. Gregory, J. Gale, F. Warren, W. Exworthy. Fred Warren and William Exworthy were to die in the First World War, their names appearing among the 119 on the war memorial who fell in that conflict.

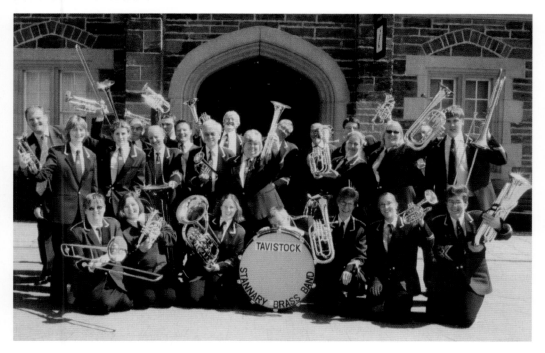

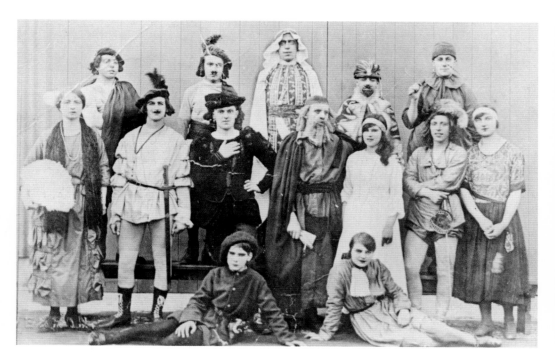

As early as the 1870s Tavistock had a thriving Choral Society. The tradition of musical performance was strengthened in 1906 by the establishment of an Amateur Operatic Society. The latter continues to give regular performances, of which "Half a Sixpence" (below) in 1978 is an example. A hardy feature of the dramatic scene, "The Tavonians" date from 1935. The other picture is a one-off from 1923. An adult education class studying drama in the thriving "evening school" in the Plymouth Road School, presents "The Merchant of Venice".

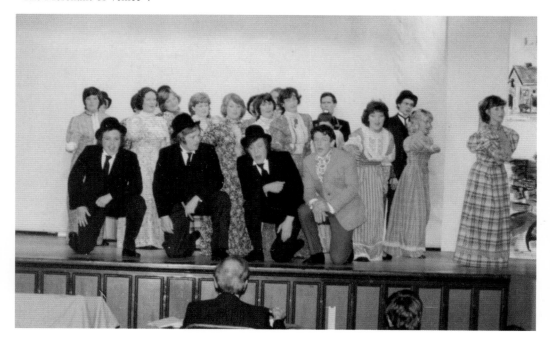

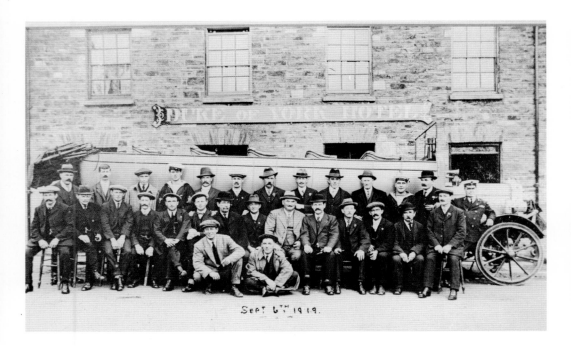

Above: The charabanc is ready for a day out, and the starting point is the Duke of York. The date, 1919, and the faces, suggest that this might have been an ex-servicemen's outing, conceivably by founder-members of the "Comrades of the Great War", the forerunner of the British Legion. Below: The Guilders, a late twentieth-century gentlemen's society. (Note the lapel of Bert Wood, licensed victualler, standing second left). The prevailing purposes are to enjoy each other's company and to raise money for good causes.

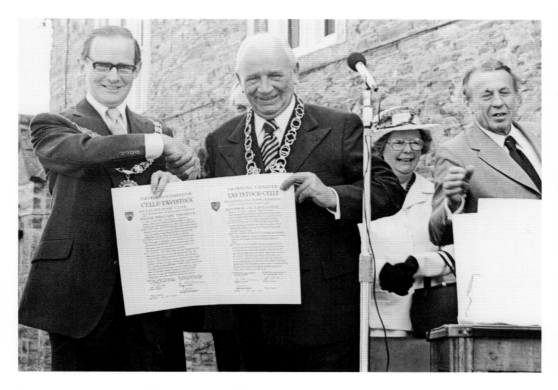

In 1977, on the twenty-fifth anniversary of the formation of an Anglo-German youth exchange scheme between the two towns, Tavistock and Celle became formally twinned. Messrs Philpott and Horstman display the twinning charter at the ceremony in Bedford Square. Tavistock's other twin is the French town of Pontivy. Here, before his town's war memorial, Mayor Masson shares a moment of homage with his German and English counterparts in 1982.

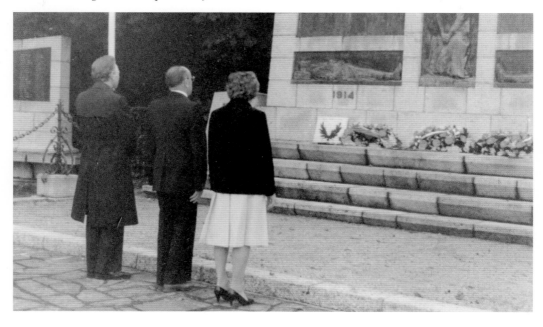

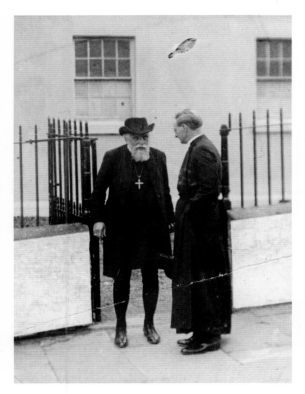

Visiting dignitaries are welcomed. In 1933 the Bishop of Exeter, Lord William Cecil, is greeted by the Vicar of Tavistock, Rev Hugh Bickersteth, on the occasion of the opening of the church hall. In 2001 the marquis of Tavistock, accompanied by the Marchioness, visits the town hall, built by his ancestor. Their guides are the Mayor and her consort. The Marquess succeeded to the dukedom in 2002, but sadly died in the following year.

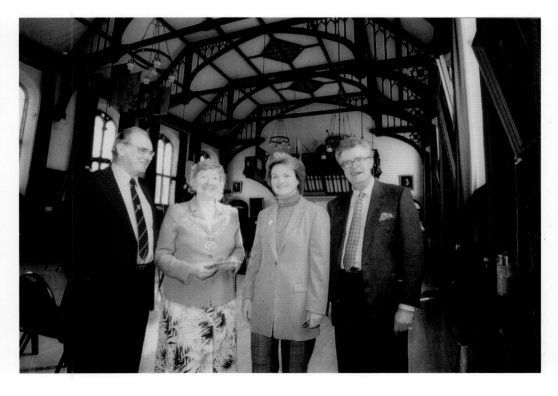

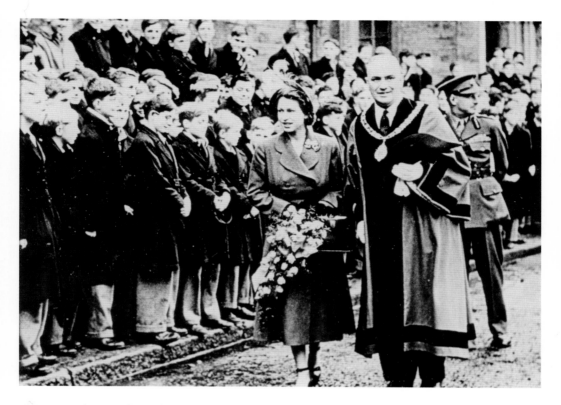

Visiting royals are welcomed. In 1949 Princess Elizabeth paid a visit, three years before her accession to the throne. She was greeted by the council chairman, Stanley Willis. In 1989 Prince Edward came to town, opened the new swimming bath, shook some hands in Bedford Square, and was warmly received.

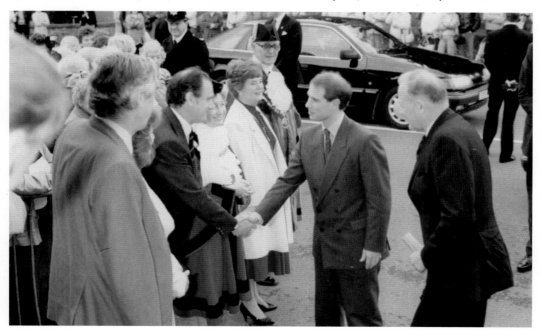

Media personalities are welcomed. 1960s : Brian Johnstone, for *Down Your Way* interviews Tavistock personality John Doidge, and friend. 1980s : Hugh Scully and the *Antiques Road Show* call in for the first of two visits. The pair of civic maces are featured, admired, and valued. They were given to the town in 1761 by the fourth Duke of Bedford. (Recent research has revealed that the Duke, notoriously thrifty, recouped the cost of the gift from payments made to him by the two men recently elected as Tavistock's MPs, who had, in effect, bought their seats from the Duke, who saw Tavistock as his "pocket borough".)

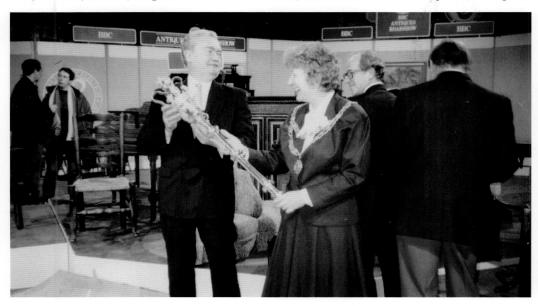